THE
Archive Photographs
SERIES

CHATTERIS

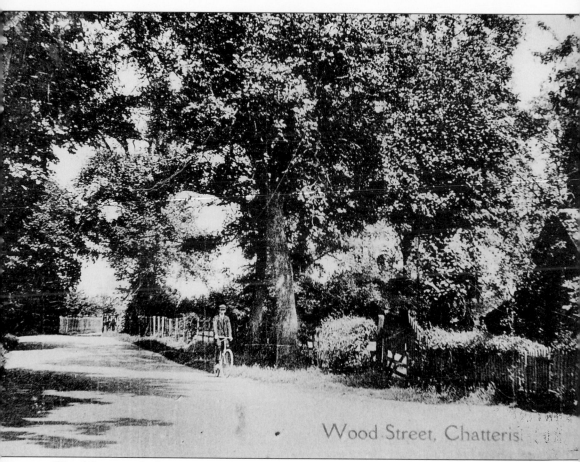

Wood Street at the beginning of the century.

THE
Archive Photographs
SERIES

CHATTERIS

Compiled by
Rita Goodger and Andrew Spooner

CHALFORD

First published 1997
Copyright © Rita Goodger and Andrew Spooner, 1997

The Chalford Publishing Company
St Mary's Mill, Chalford,
Stroud, Gloucestershire, GL6 8NX

ISBN 0 7524 0762 7

Typesetting and origination by
The Chalford Publishing Company
Printed in Great Britain by
Bailey Print, Dursley, Gloucestershire

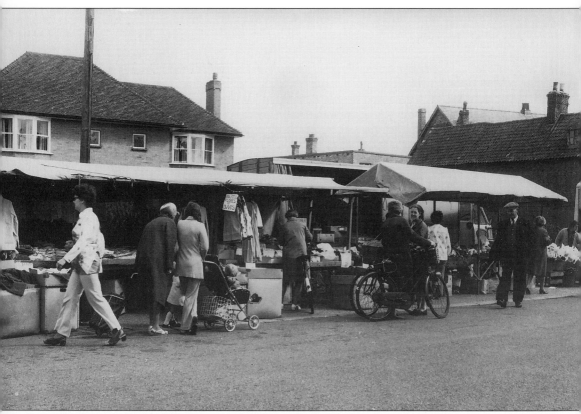

Chatteris is a small market town and Friday is market day. It is now held in Park Street and this picture taken in 1974 shows an assortment of stalls, the most popular ones are the fruit and vegetable, fish, and the flower and plant stalls. For many, Friday is shopping day, when you meet friends and chat.

Contents

Acknowledgements

We would like to thank Chatteris Museum and all those who have supplied information or photographs, including: Margaret Allen, Violet Brown, Egbert Dwelly, Hazel Francis, David Green, Joyce and Harold Hammerton, Douglas Heading, Joan Hooper, Barry Limbrick, Joan Margetts, Betty Munns, Hilda and John Salisbury, Peter and Pauline Short, Stuart Stacey, Peggy Stratton, Jack Sutherall, Christine Thrower, Doris Walsh and Gemma Watts.

Rita Goodger and Andrew Spooner

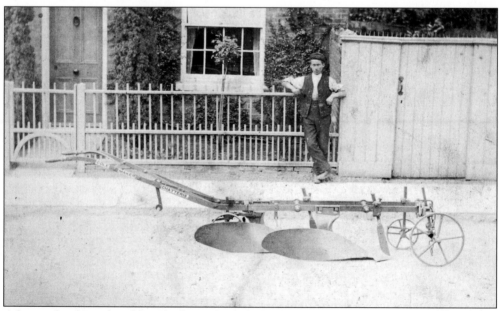

A horse plough produced by Charles Cole, agricultural implement maker and iron founder, of London Road.

Introduction

Chatteris is situated between the cathedral cities of Ely and Peterborough, the former some twelve miles and the latter some eighteen miles distant.

The town stands on a clay island, thirty feet above sea level and surrounded by the rich fen soil of North Cambridgeshire known as the Isle of Ely, forming a centre of a thriving agricultural area noted for its carrots, potatoes, celery, onions and beet crops. The fertile peat based soil has been brought under cultivation by vast drainage schemes, first started by the Romans, and completed during the seventeenth century by the Dutch engineer Vermuyden working for the Duke of Bedford. As a settlement Cetriz or Cateriz started as an iron age village on the low ridge of Langwood just south of the present town. This site was later occupied by the Romans forming a trade link from Huntingdonshire towards Wisbech. The Roman settlement was quite substantial with a stone built administration building in the centre of the community. The surrounding land was farmed, not as individual villa farms but as a large imperial farm growing crops for transportation to other parts of Roman Britain. The Old West River, now lost through drainage but remaining as a stable bed for the Chatteris to Somersham road, formed part of the Roman canal/river system to the north.

A small early medieval settlement on the site of the present town possibly grew up to serve the convent or nunnery founded in about 980AD. This was the last of nine such religious sites built before the Norman conquest in 1066. In 1538 it was designated as an abbey and known as the Abbey of St Mary. It was situated on the north side of Victoria Street and bounded by the present Park Streets. All remains of the building disappeared in 1847 when the large mansion formed from the original building and owned by the Gascoyne family was demolished. Stones 'quarried' from the ruins can be seen in many nineteenth century houses, particularly Seymour Place on London Road built in 1847. Several surviving lengths of boundary wall still exist in East and South Park Streets.

Over several centuries, six separate manors existed in the town, however, the population rarely exceeded 2,500. Population growth started during the first half of the nineteenth century, census information reveals fifteen inns and forty-three beerhouses, three saddler and harness makers, six blacksmiths, six wheelwrights, thirteen boot and shoe makers, thirteen grocers, twelve bakers and twenty-one separate outlets for clothing including tailors, dressmakers, drapers and straw hat makers among the many other businesses serving the town.

Deaths averaged about one hundred a year during this time, a quarter of them were children under one year old. Many diseases were endemic, particularly typhoid, cholera, smallpox and

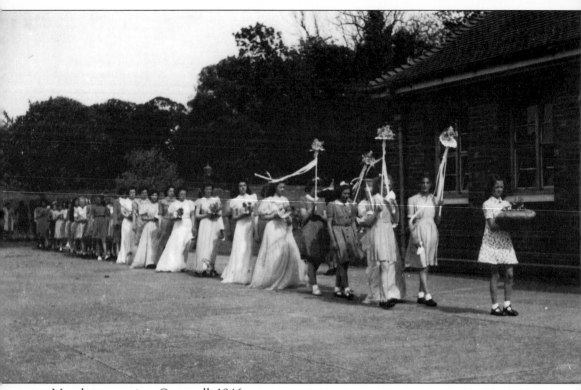

May day procession, Cromwell, 1946.

the ague; a form of fenland malaria. In 1832 a cholera outbreak affected over two hundred people with many deaths, a mass grave once existed in New Road. Many of these infectious diseases were caused by poor sanitation and water supplies, in 1889 all the town's wells were polluted by effluent. Piped water reached Chatteris in April 1907.

The enclosure of land during the early part of the nineteenth century encouraged the agricultural population to grow. The system of agricultural gangs using women and children originated at this time. In 1931, fifty seven and a half per cent of the male population were engaged in agricultural work.

During the 1890s Chatteris Engineering Works grew to supply the many needs of the South African diamond and gold mining industries. At one time it is estimated that ninety per cent of the engineering equipment required by the De Beers diamond mining companies originated in Chatteris, and Francistown in Botswana is reputedly named after a Chatteris engineer.

Recently many changes have taken place with new housing estates and specialised industries emerging in the town, however, agriculture will continue to dominate the scene for many years to come.

Rita Goodger and Andrew Spooner
July 1997

One
Street Scenes

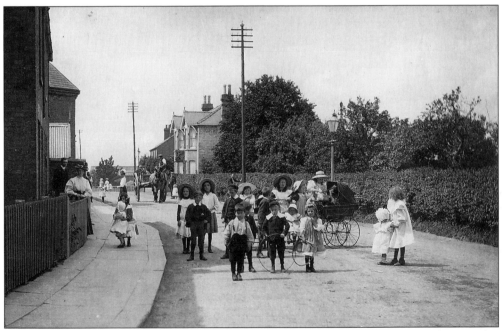

Station Street at the beginning of the century when the only traffic was horse and cart and it was quite safe for the children to play in the road.

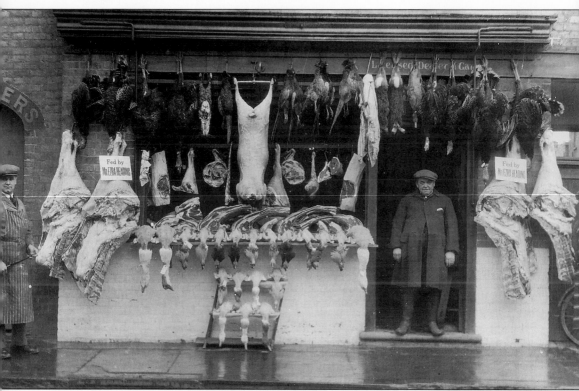

One of several butchers shops in Chatteris, which is now the only one left in existence, photographed in the first half of the century. Situated in Park Street, it was run for many years by the Scott family. At the time this picture was taken, meat was produced locally, some of it is labelled 'Fed by Ezra Heading' who was a local farmer. The assistant on the left is Harry Starkey, a well-known figure in Chatteris, as he started and ran for many years, a pork butchers shop in Huntingdon Road.

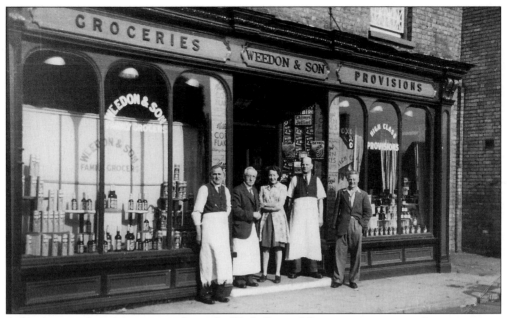

A family-owned grocery store at the end of Park Street. The two assistants in white aprons are Mr Mattock and Mr Boulton, together with three generations of the Weedon family. Thomas Weedon, his son Harry Weedon and his daughter Pauline whose husband, Ray Davies joined the business after the war together with Tom Weedon, Pauline's brother. Today it is an Indian take-away.

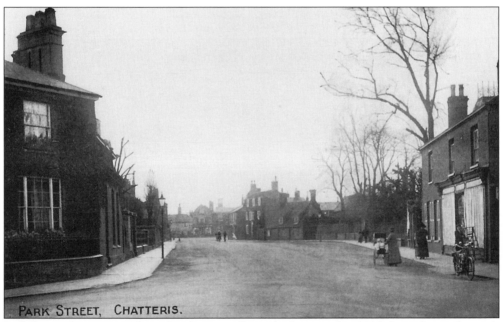

Park Street showing, on the right, the post office, which opened in 1924. It is a late eighteenth century building with a pedimented doorway with fanlight and bow windows above. A telephone service for Chatteris was first provided in 1910. The thatched cottages and the Priory were demolished and have been replaced by a garage and a swimming pool.

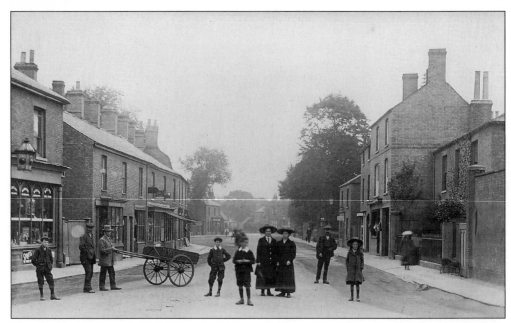

The shops and houses in Park Street looking much the same as they do today, but the gas light and the dress date the picture.

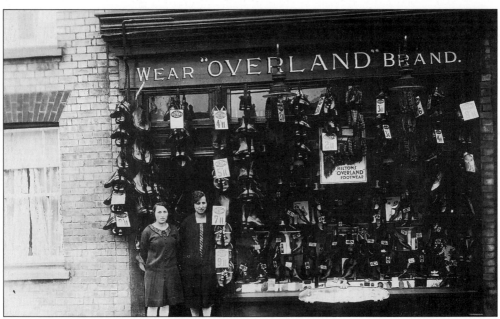

The shoe shop on the corner of Market Hill, formerly a butchers which was taken over by Hiltons.

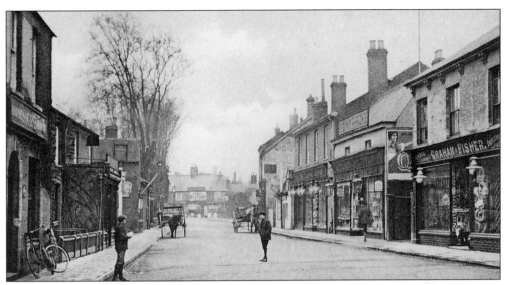

High Street at the beginning of the century.

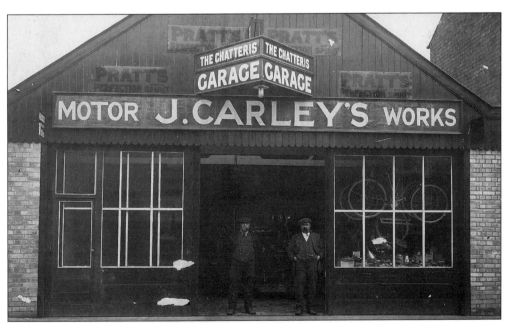

Mr Carley in front of his garage in Bridge Street. At the back was a yard where he kept all his steam engines. During the General Strike in 1926, they were used to take vegetables up to London for sale, a journey which took three days.

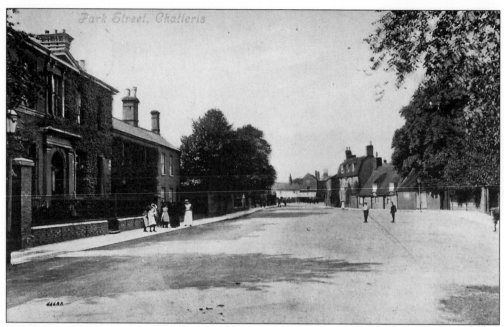

Park Street. The ivy-covered building on the left is Park House. The trees on the right stood in front of an old house, 'The Priory'. Later it was demolished to make way for the Empress cinema, which has now become the Empress swimming pool.

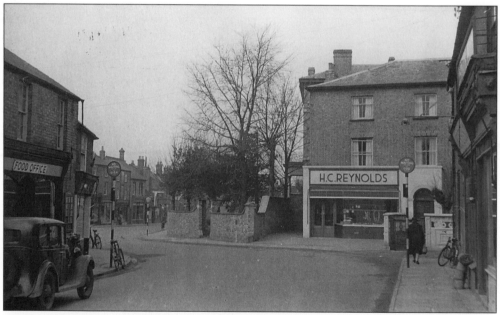

A part of High Street just after the Second World War. The shop on the left was used as a local office for the Ministry of Food. The large house, 'Bramley House', named by a fruit farmer, was bought by H.C. Reynolds, a butcher who changed the front into a shop and built his own slaughter house in the grounds. Later it was a dress shop and today it is a guest house.

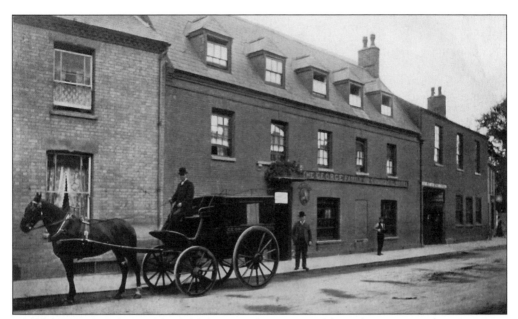

'Ye Olde George Hotel' in the High Street. This was an old coaching inn on the main route from Kings Lynn to London. The six horse coach, *The Defiance*, left the George at 9a.m. every Tuesday, Thursday and Saturday. After the building of the railway in 1848 the first omnibus in Chatteris collected passengers from the station for the hotel.

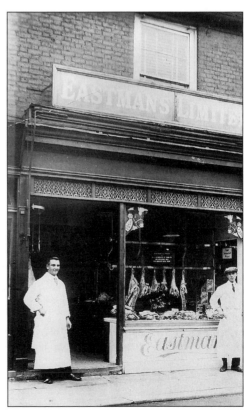

Mr Sparrow, the manager, and his assistant, Mr Gunstead, in front of Eastman's butcher's shop in the High Street.

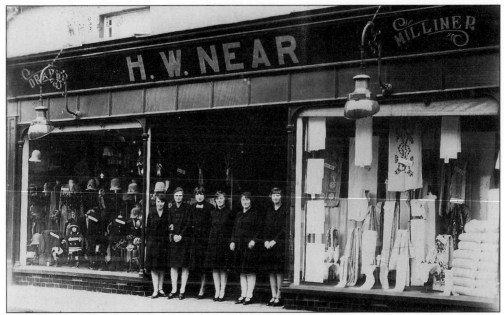

Herbert Near, assisted by his wife and a team of ladies, ran a very successful business in the High Street during the 1920s and 1930s. They catered for all ages and sizes, and held a large stock of clothing. Whether you wanted a small item of haberdashery, bed linen, a new hat, or towelling to make babies nappies, you could always buy it at Near's.

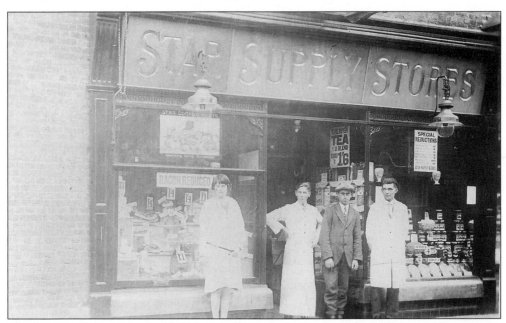

The Star Supply Stores in the High Street, photographed in the thirties when competition was keen. The price of bacon was reduced, tea was only one shilling and sixpence (7p) a quarter, and there is a list of other reductions. Note the old gas lamps illuminating the shop front.

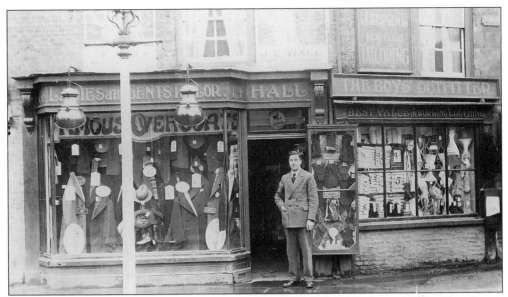

J.E. Hall, ladies and gents tailor, boys outfitter and best value in working clothes. This shop is situated in the High Street at the corner of King Edward Lane. Prior to the Second World War most people shopped in their home town and a suit made to measure could be purchased for three guineas! As darkness fell, the gas lighter could be seen cycling round the town turning on the lights.

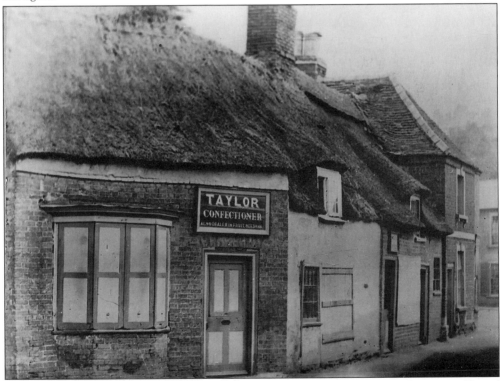

The corner of Park Street and Market Hill. Taylor, the confectioner, was known as 'Satan' Taylor due to his practice of trading on a Sunday.

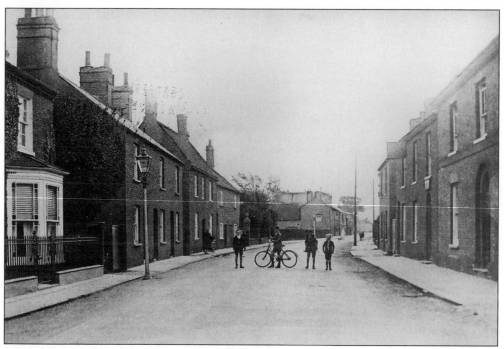

London Road in the 1920s. The Cock public house is on the right.

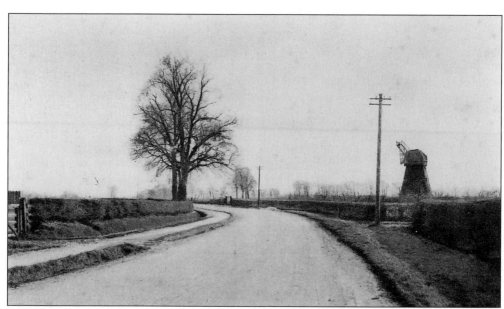

Early in the century, before London Road was developed and the derelict Black Mill was still standing. Now remembered in the development of Black Mill Road.

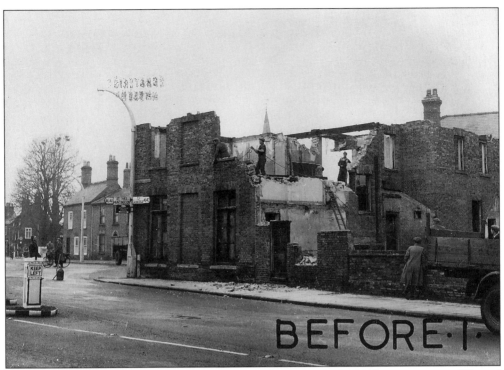

Market Hill. Workmen are demolishing a house which was the home for many years of Dr and Mrs Nix. Demolition was to improve the visibility at the road junction.

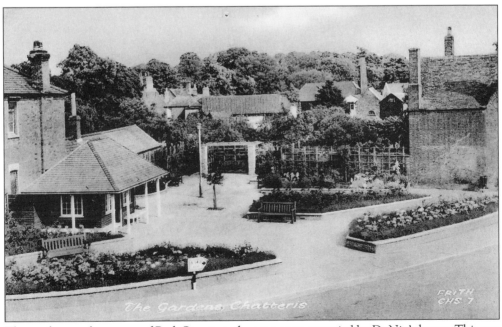

The gardens at the corner of Park Street on the area once occupied by Dr Nix's house. This was taken at their opening in 1962 when it won a Civic Trust Award.

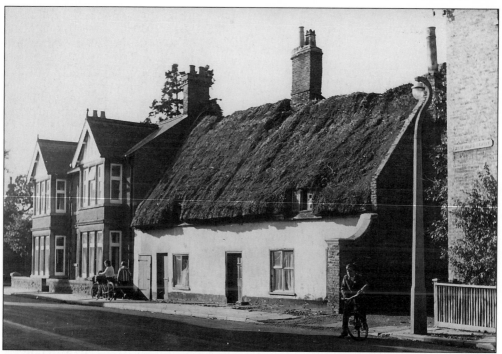

The Red Lion public house in West Park Street, October 1965.

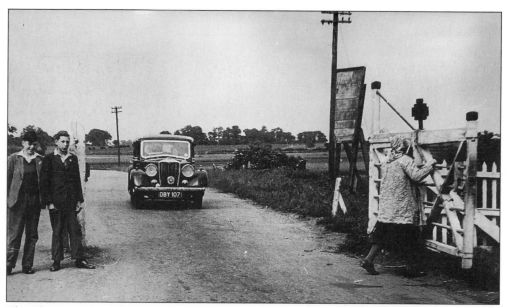

The Chatteris ferry toll on the Somersham Road. Under the Turnpike Acts of 1663 main roads in Huntingdonshire, Cambridgeshire and Hertfordshire were maintained by raising tolls. The toll continued until 1949 and although the gates have disappeared the original 'round' toll house remains as a private house. Mrs Thorpe, the toll keeper is watched by two schoolboys, the one on the right is Maurice Ward.

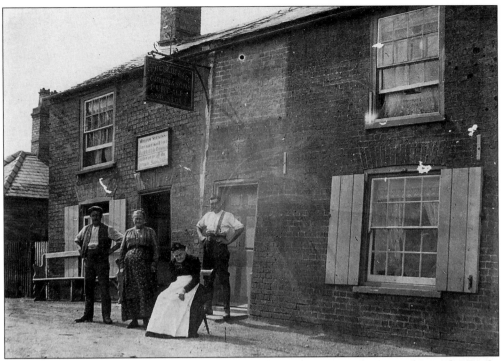

The Blue Ball public house, Ferry Hill. The two houses are now incorporated into the Crafty Fox public house.

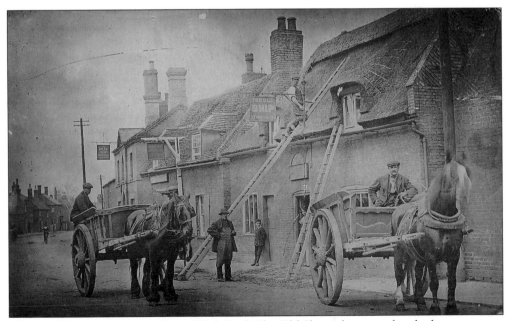

Three public houses in a row down Slade End. The Old Ship is being re-thatched.

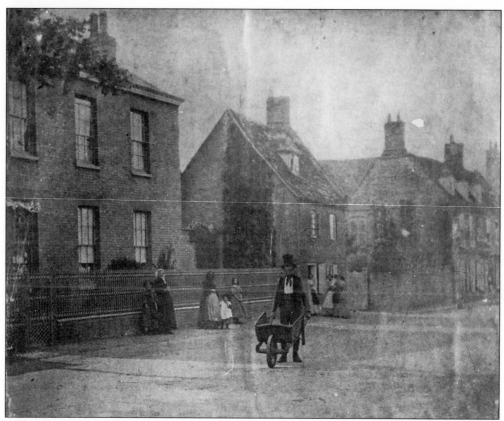

High Street. The building on the left is the Georgian property built in 1818 and known as Grove House. In 1885 the owner decided to extend the property by jacking up the roof and adding the extra storey, providing five additional rooms for £500.

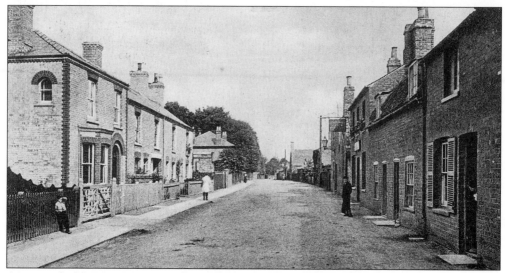

A postcard of Station Street from the Valentines series, 1904.

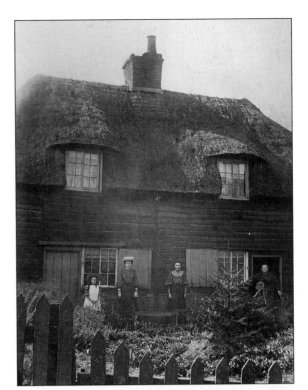

In Railway Lane stood two semi-detached wooden houses with thatched roofs. One was a beer house, and the other was occupied by Mr A. Emery who worked in the nearby factory. It burnt down in 1939 and a bungalow now stands on the site.

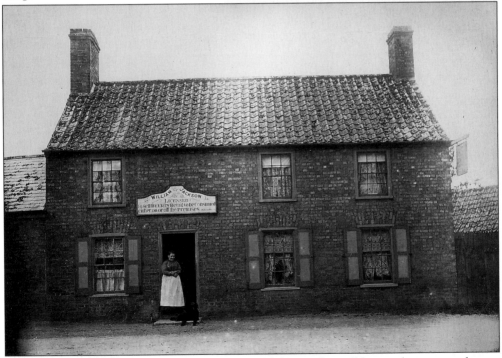

The Anchor, a beer-house at the end of New Road, licensed to sell beer to be consumed on or off the premises. Mrs Jackson with her dog is standing at the door, usually the husband had to supplement their income by doing land work.

The Cricketers in Railway Lane. Mr and Mrs H. Clarke moved there before the Great War, and in the next fifty-one years, brought up a family of seven. Mrs Clarke was teetotal. The picture shows Doris, the youngest daughter, watched by George Gathercole, who was foreman on the roads for the council.

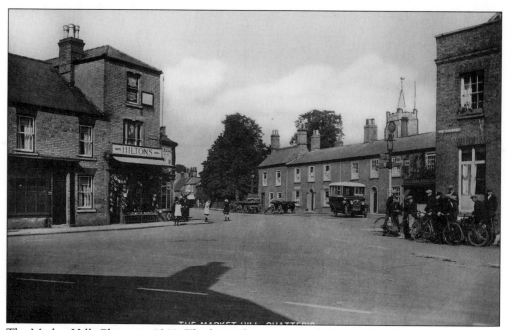

The Market Hill, Chatteris, 1941. The large chestnut tree which stood in front of the church is sadly missed. It had to be felled as it was diseased.

24

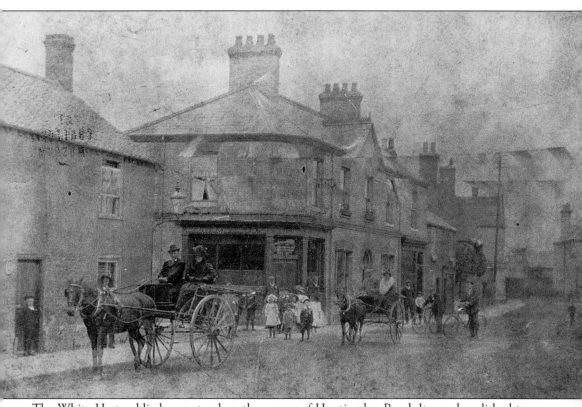

The White Hart public house stood on the corner of Huntingdon Road. It was demolished to improve vision at the junction and the space was used for a garden maintained by the local council. On the opposite corner is a garage and the house lived in at one time by the owner Walter Crawley.

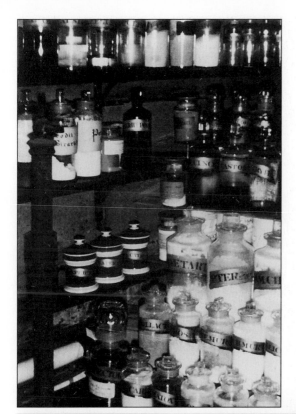

Park Street pharmacy showing an assortment of pharmaceutical containers including three blue Delft pill jars. Note the brass stand pipe for gas illumination. For many years the shop still displayed a jar of opium poppies used as a relief from the effects of ague, a form of malaria endemic in the fens.

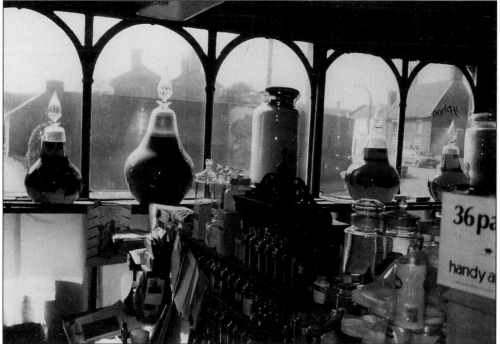

Another interior view of Hedley Dwelly's shop, showing the large bottle containers in the window.

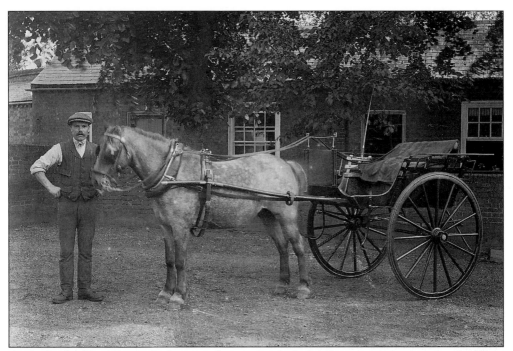

At the back of Ivy House, the horse and trap is ready for Mr Ruston to go out to visit his farm. The horse keeper is Charles Goodger.

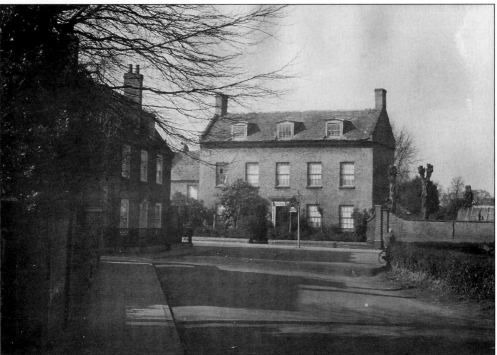

Ivy House, Station Street, was built in the eighteenth century with brick chimneys, a roof partly stone-slated, and a good doorway. The home, which for many years belonged to the Rustons, was demolished after the war.

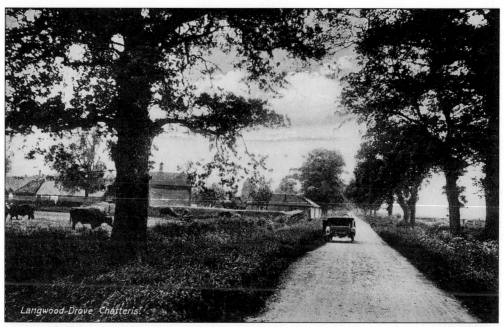

Langwood Drove in the 1920s. As the drove leaves Ireton's Way, the old military road built to Ely during the Civil War in the 1640s, it passes through the original Iron Age and Roman settlement.

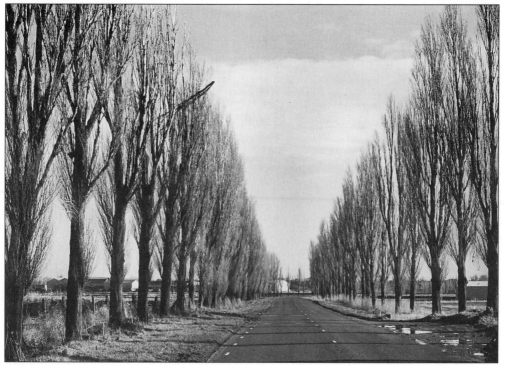

Driving along the A141 from Warboys, the motorist would pass along the avenue of poplar trees into the town. It is believed the trees were felled because their shallow root systems were affecting the stability of the road.

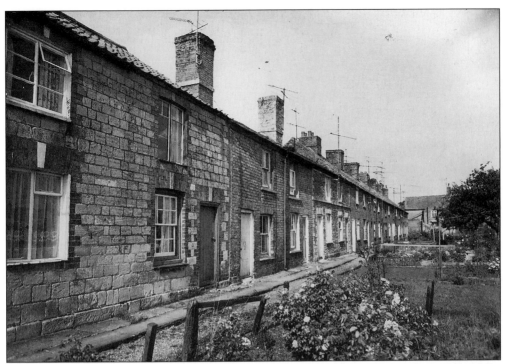

Southampton Place, also adjoining Curtis' Row and Seymour Place. During the middle of the nineteenth century these terraces along with Hive End and Slade End were notorious for outbreaks of typhoid and cholera.

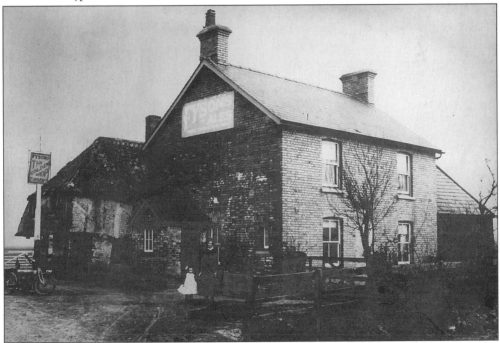

The Golden Drop beer house, the half way point to Warboys, would have catered for local land workers.

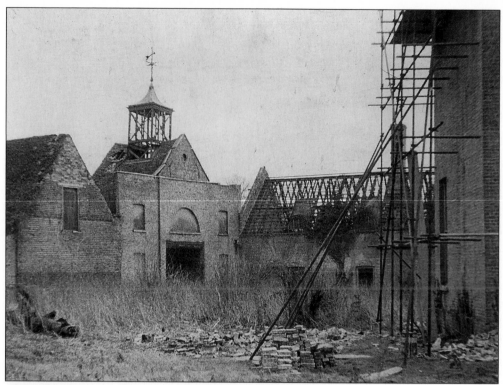

Chatteris Manor in Wenny Road. By the turn of the nineteenth century many of the outbuildings, particularly the stables, had fallen into disrepair.

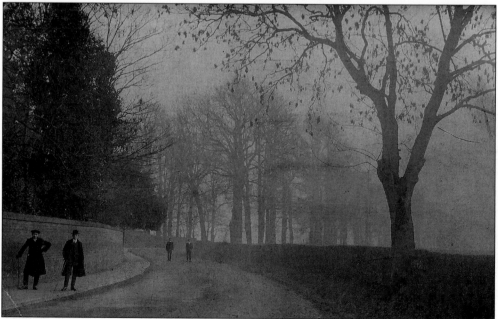

A favourite Sunday afternoon walk was along Wenny Road to Tucks Gate. This view down past the manor house has completely changed with the building of Cromwell Community College in 1938.

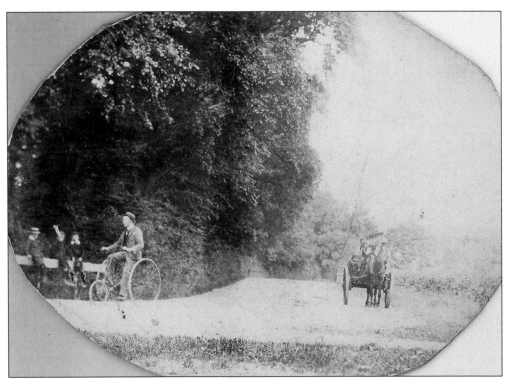

Wenny Corner with Tucks Gate to the right in the 1890s.

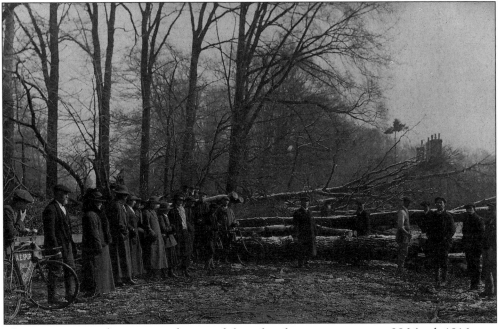

The same scene as the previous photograph but after the severe storms on 28 March 1916.

Continuing the Sunday afternoon walk past Tucks Gate to the entrance of Robin Knights Lane, a popular drove for blackberry picking in late summer.

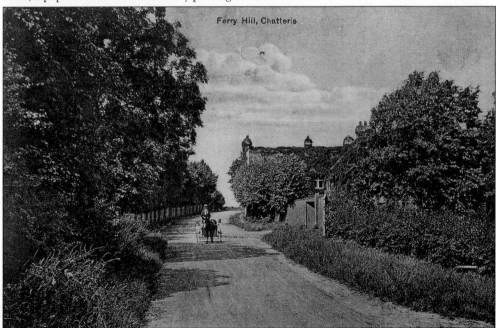

Ferry Hill, Chatteris. The house on the right was the home of Mr and Mrs Leonard Childs. In 1928 during a night of very strong winds, a passing locomotive on the St Ives to Chatteris line showered sparks onto a thatched barn and the resulting fire spread burning brands onto the roof of the Childs' home, burning it to the ground. Only two weeks earlier Mrs Childs had presented the keys to Chatteris Fire Brigade for the first motorised fire engine, her burning home was its first call.

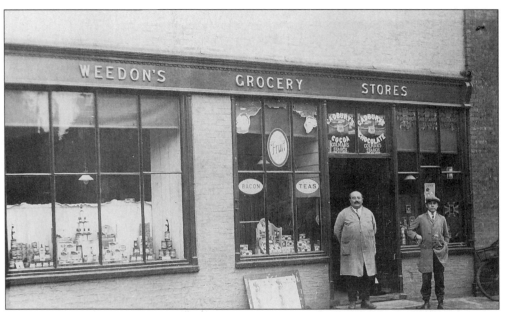
Thomas Weedon's second shop in West Park Street. Mr Makeham stands in the doorway.

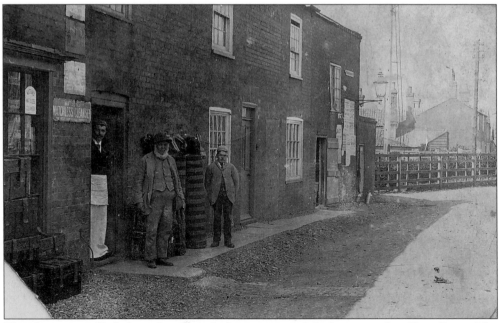
This shop originally belonged to Isaac Jackson, a general dealer situated in Hive Street. The property escaped serious damage during the Great Fire of Chatteris in 1864. The road was renamed Anchor Street soon afterwards to commemorate the miraculous survival of the Crown and Anchor public house. After the Great War the street underwent a further name change to Clare Street, commemorating George Clare VC.

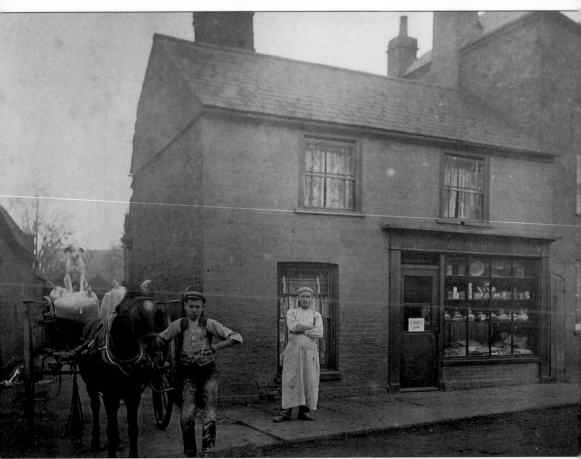

Samual Dobbs, the baker in the High Street.

Scotney, the barber in High Street.

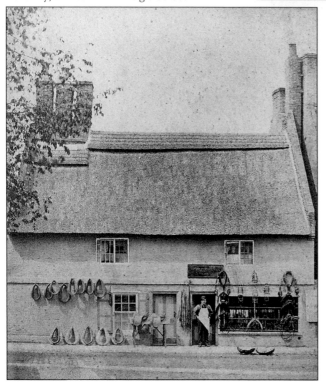

With the exception of the steam traction engine, the horse dominated all heavy labour on the farm during the nineteenth century. In 1858 the trade directory for Chatteris listed three saddlers and harness makers, six blacksmiths, six wheelwrights, four agricultural machinery manufacturers and one owner of steam threshing equipment. This saddlers' business was situated in Market Hill and is now occupied by the National Westminster bank.

35

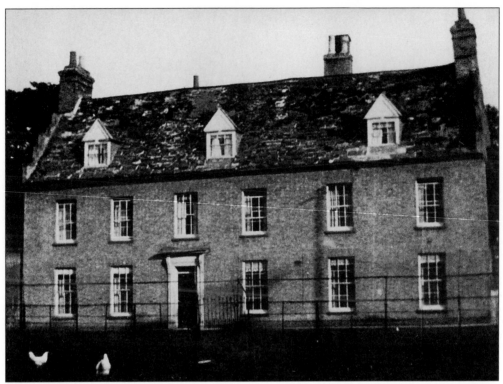

The Shrubberies, St Martins Road. A large seventeenth century home with a brick chimney dated 1605, stepped and Dutch gables and a roof partly stone slated, was the home for many years of the Richardson family.

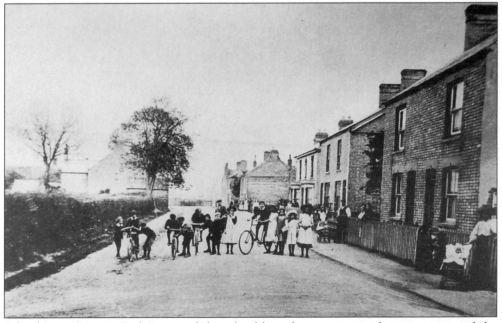

School Lane, Manea. Back Lane and the school have long since gone but once occupied the site where the village hall stands today.

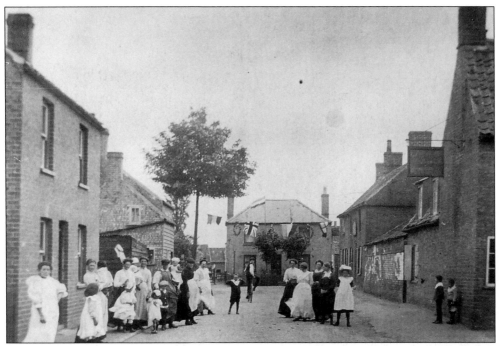

East Street, Manea led down to the clay pits and the brick kiln.

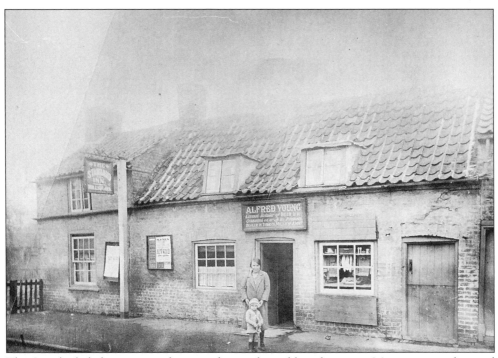

The Standard ale house, one of twenty-three pubs and beer houses in Manea, was nicknamed the 'Flea and Flannel'. The shop selling second-hand goods was opened once a week by the shopkeeper who travelled in by train. Today the police house stands on this site.

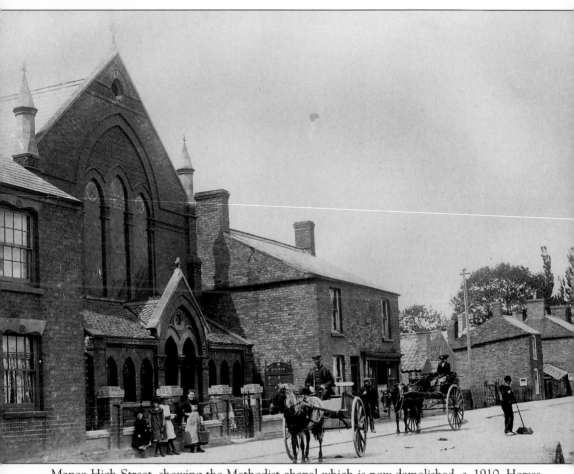

Manea High Street, showing the Methodist chapel which is now demolished, *c.* 1910. Horses and carts were used by the people living out in the fen to come to shop - more work for the road-sweeper! The cottages on the extreme left and right still stand, as does the one beyond the chapel which was Fred Stokes' butchers shop. Further along stood a shop used by confectionery rock-maker, William Thompson, who attended all the local fairs.

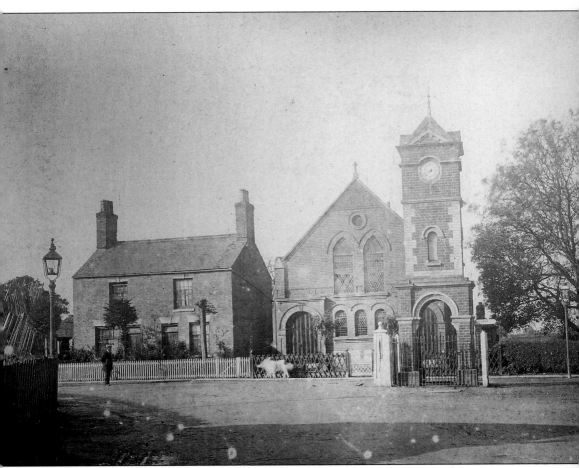

Doddington sits on fenland's largest island after Ely and it is just twenty-five feet above sea level. The clock tower was erected at a cost of £80 to commemorate Queen Victoria's diamond jubilee in 1897. The spire and weathervane were added in 1911, but in 1937, the county surveyor suggested it should be removed from the middle of the road to its present site. This was done by Bert Collins, a local builder. The house to the left of the Wesleyan chapel was built by John Yorke in 1850. Named 'Alpha Cottage', it has stayed with the same family, and today his great-great-great grand-daughter, Gemma Watts, lives in it with her family.

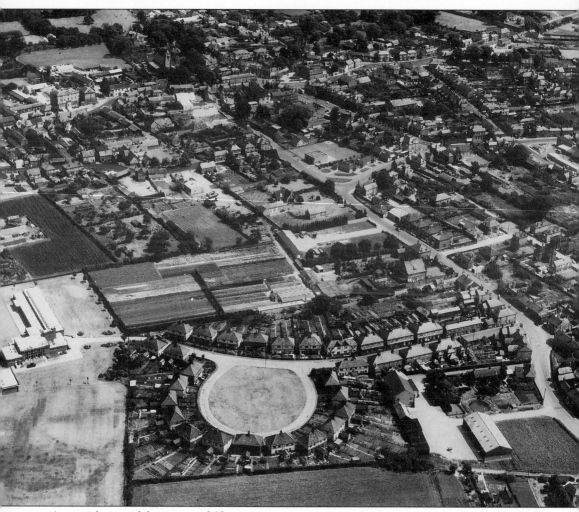

An aerial view of the centre of Chatteris.

Two
Sports

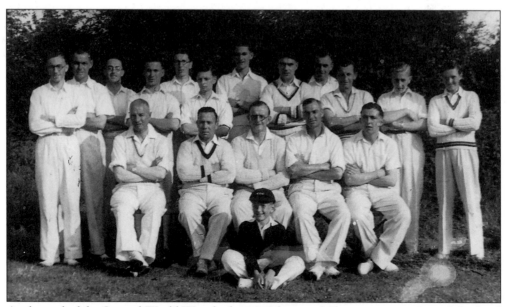

At the end of the Second World War the keen cricketers of Chatteris soon reformed the local team.

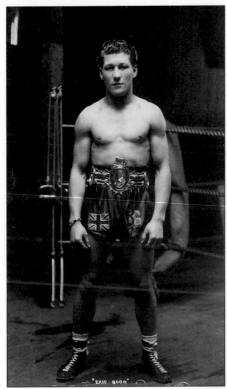

Eric Boon, when he became the Lightweight
Champion of Great Britain in 1939.

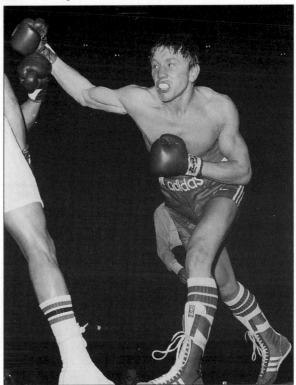

Dave 'Boy' Green in action. He
became the British and European
Light Welterweight and European
Welterweight Champion.

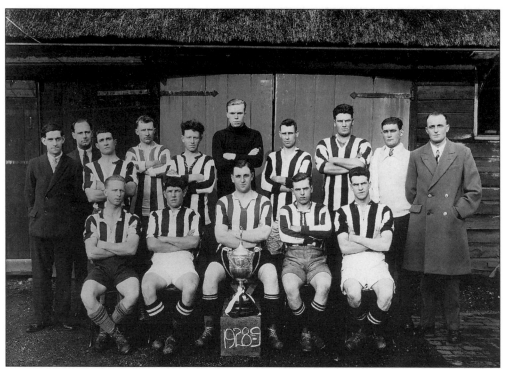

The Chatteris Engineers football team, 1928-29. At this time they played on the York House grounds in London Road but they later moved to Tucks Gate, Wenny Road. The gentleman in the overcoat on the right is Mr C. Young, the vice-president of the club and his brother, Roland Young, a member of the team, is sitting behind the cup.

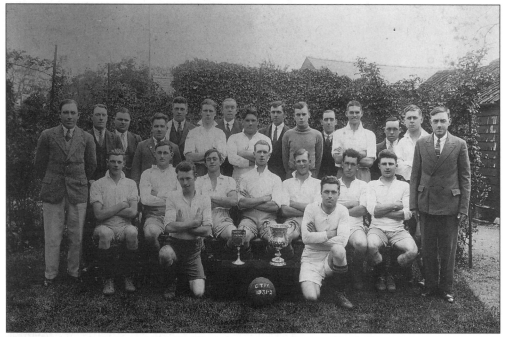

The Town Football Club, 1931-32. Their home ground was at Birch Fen.

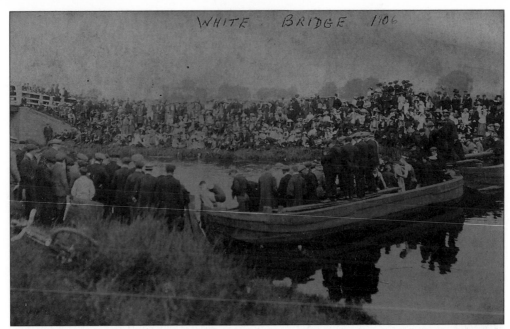

A swimming gala at White Bridge on the Sixteen Foot, 1906. This, for many years, was the only accessible spot for locals to swim in relative safety. In the late 1920s, Miss Q. Palmer, a teacher at the New Road Girls school and a proud owner of an Austin Seven would take three of her pupils for a swim after school.

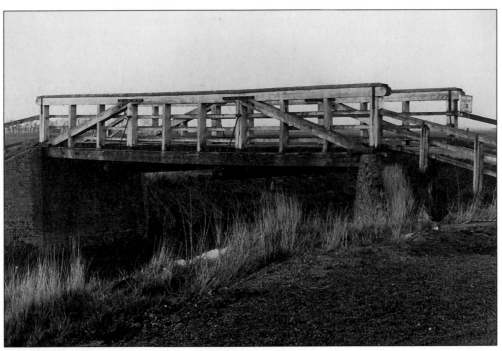

White Bridge, Horseway, which was demolished in 1980.

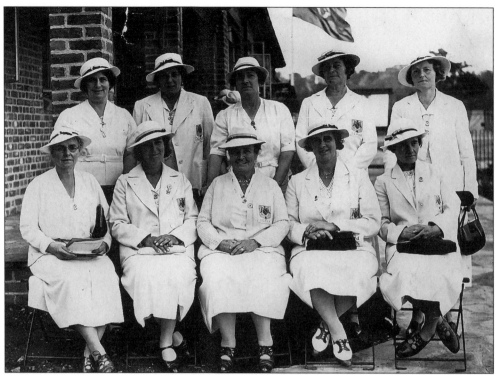

Bowls has always been a popular game in Chatteris for ladies and gentlemen. This photograph was taken in 1939 when the ladies represented Chatteris at a tournament in Wimbledon.

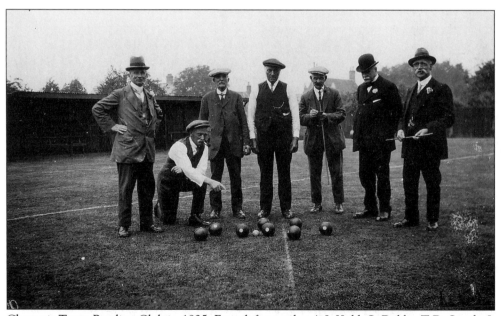

Chatteris Town Bowling Club in 1925. From left to right: A.J. Kidd, S. Dobbs, T.D. Smith, I. Sneesby, R. Cooper, S. Parsons and C. Heading.

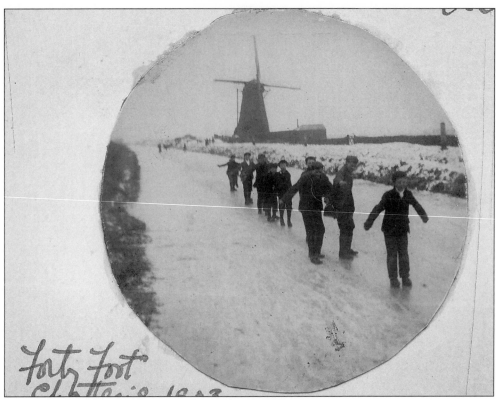

Skating on the Forty Foot River in the winter of 1903.

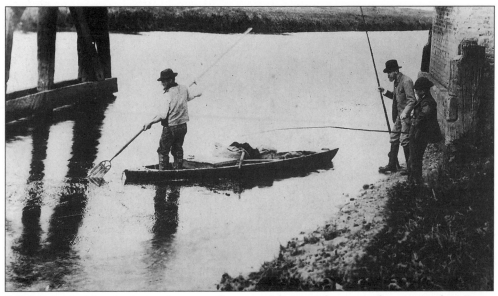

Eel gleaving at Mepal, when eels were still a great delicacy! The centre figure is Herbert Fryer, who lived at The Priory in Park Street, Chatteris.

Three
School Days

Cromwell school, opened in 1938, later became a secondary modern school and is now a community college. It has a wide catchment area with children coming from Manea, Doddington and Benwick.

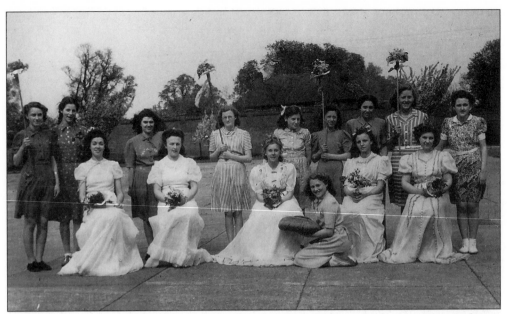

When the Cromwell boys and the Cromwell girls each had their own head teacher and were run independently, the most popular event of the year for the girls was the crowning of the May Queen. On a Saturday in May, after weeks of rehearsing, a procession of the whole school, singing chants, would take place. Parents and friends were entertained with country dancing. The new queen, elected by popular vote, was crowned by the queen of the previous year. Her dress, made by a member of staff, was a secret until the day, which meant the measurements of the entire form from which the queen was taken had to be recorded. The day finished with the performance of a three-act play by the staff and pupils.

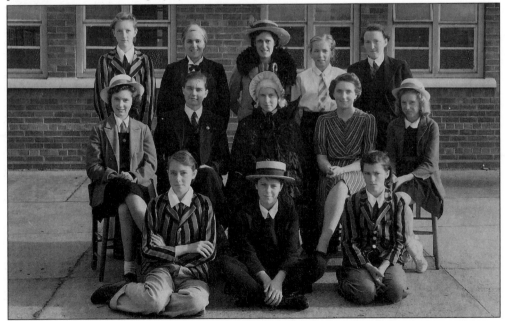

The staff and some of the senior girls of the Cromwell girls school dressed for their production of a three-act play on the evening of a May day.

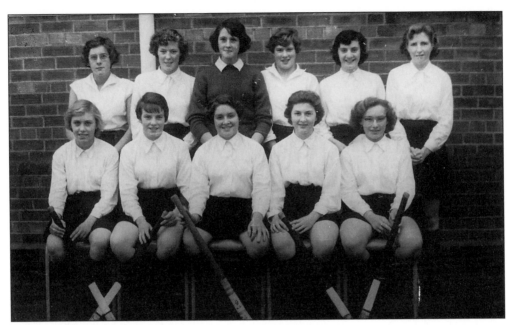

A Cromwell girls hockey team.

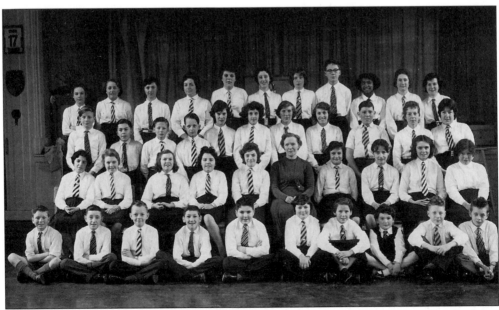

Miss Vera Heading was for many years in charge of the music at the Cromwell school and trained a splendid mixed choir who led the singing in assemblies and performed at many school functions.

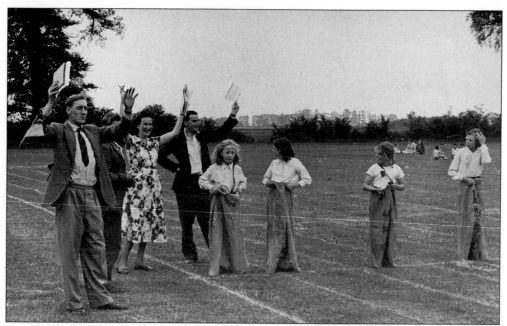

Before athletics were taken seriously at Cromwell school, the boys and girls joined for a sports day in the summer term. One of the highlights was the sack race.

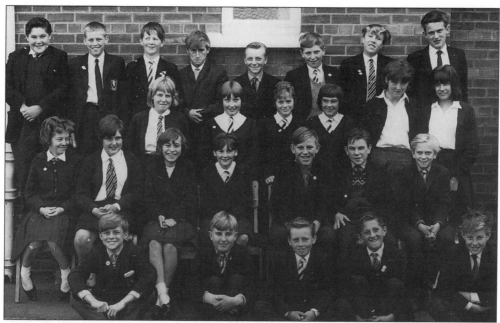

A first year mixed form at the Cromwell school. Second from the left in the front row is Alan Melton. He became the Chatteris representative on the Cambridgeshire County Council in 1997.

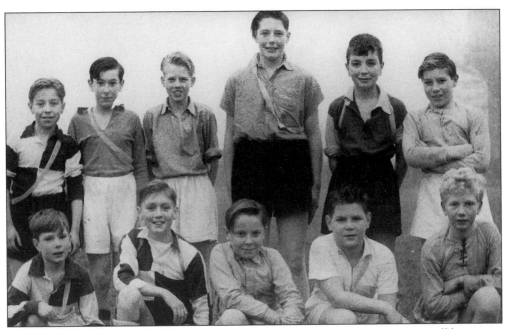

Football has always been a popular game in the Fens and in this group of a Cromwell boys team is Raymond Goodjohn (the tall boy on the back row).

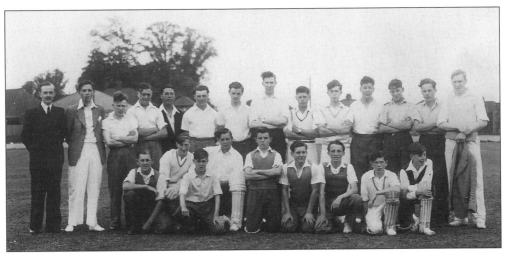

For many years the Cromwell Old Pupils Association flourished and during the summer sporting events were arranged. This is a group photographed after a cricket match, held between the school and the 'old boys'.

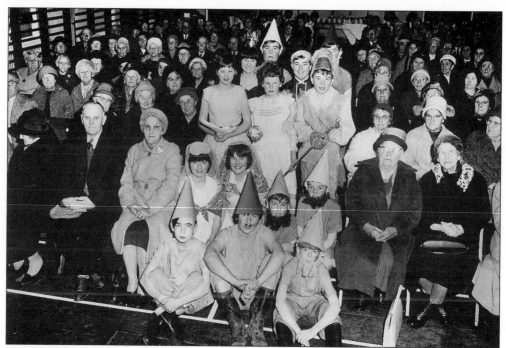

Cromwell school invited the Good Companions and other Senior Citizen Clubs in the area to their Harvest Festival Service and to entertainment at Christmas. Among the audience are members of the cast of *Snow White*.

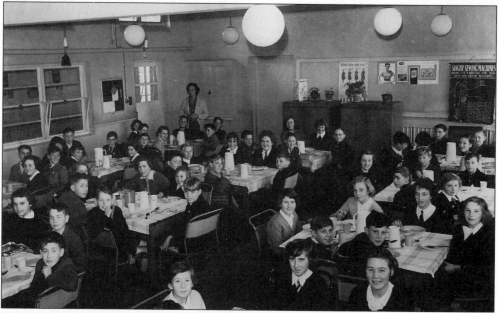

When the Cromwell school opened in 1938, two classrooms had to be used for dining rooms. Lessons finished five minutes early in these rooms to give the pupils time to set the tables ready for the queue outside to come in, meals cost 9d (3.5p). One member of staff was on duty, grace was said, lunch was served by kitchen staff and the tables reset for the second sitting. All was quiet and orderly with a table leaving at a time.

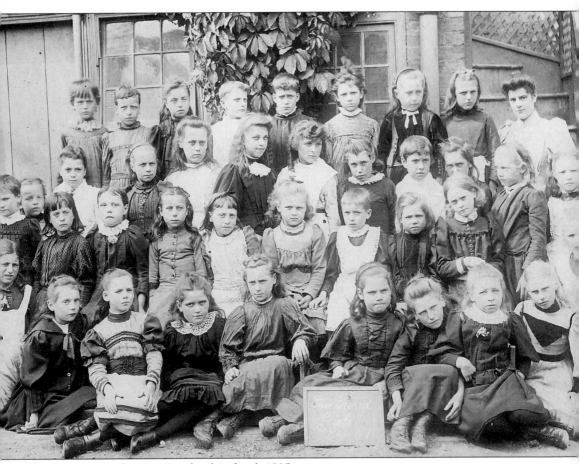

A class group at the New Road girls' school, 1895.

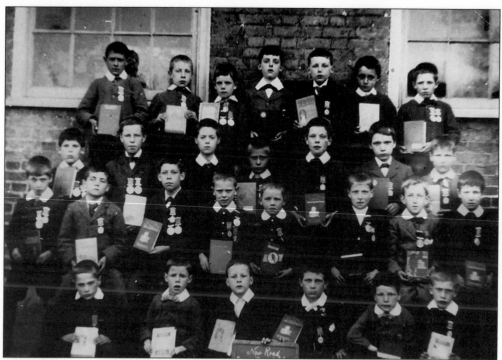

New Road Board School, 1901. The boys are displaying their end of year prizes and medals, issued by the Isle of Ely Education Committee for a year's full attendance.

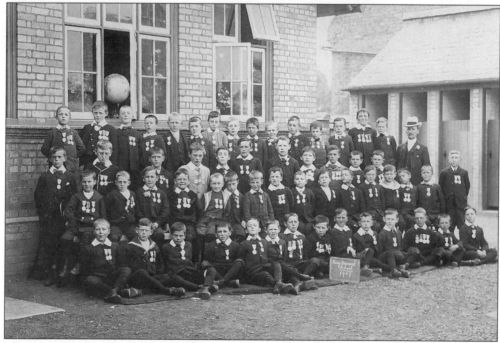

The boys with their headmaster, Mr A.J. Kidd, are settled in their new school, all very smart and wearing their attendance medals, 1911. A globe has pride of place in the window, the toilets have long since been demolished.

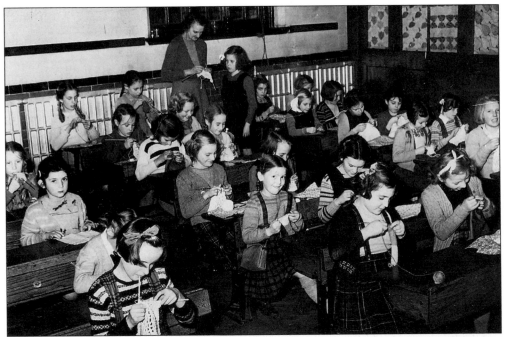

A busy classroom at King Edward school. The 'knitting' lesson is taken by Miss Hilda Warth. When war broke out the pupils were moved to the Cromwell school leaving this building free for an evacuated school.

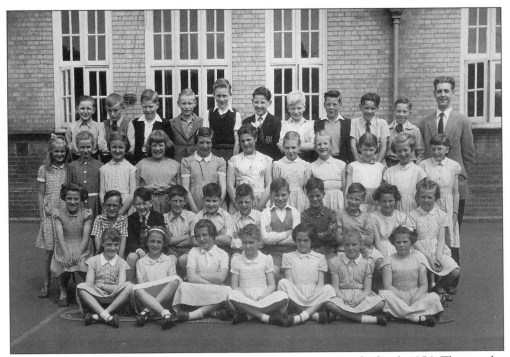

Pupils at the King Edward County Primary school, by now a mixed school, 1956. The popular young master was Mr Howarth.

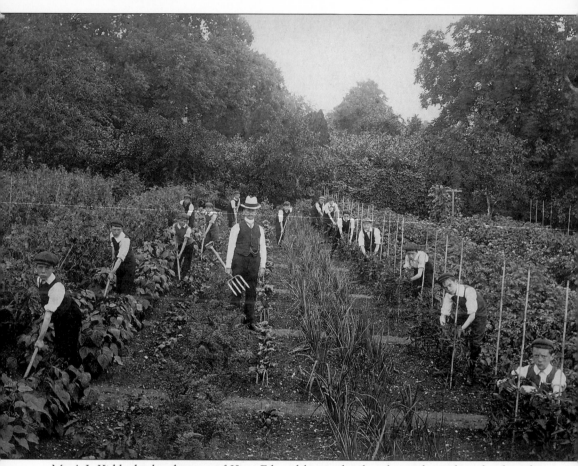

Mr A.J. Kidd, the headmaster of King Edward boys school with pupils in the school garden adjacent to Mr Kidd's house in St Martins Lane. The fourteen plots were originally part of the kitchen garden for the old vicarage.

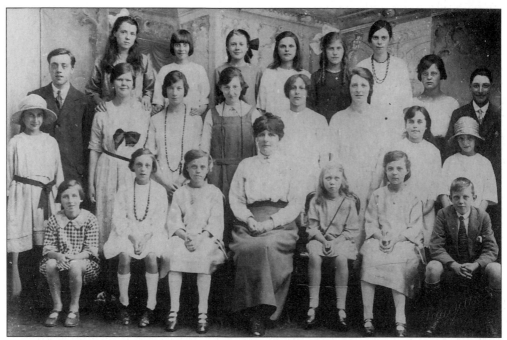

A group of children who are pianoforte pupils of Mrs J. Lambe (seated in middle), 1925. Her husband, Joe Lambe was the last town crier. On the back row second from right is Ivy Skeels, who later took pupils herself. In the second row, Mrs Lambe's daughter Constance is standing to the right of her mother's shoulder. Palmer-Hayes, the boy on the front row later became a well-known business man and councillor in Chatteris.

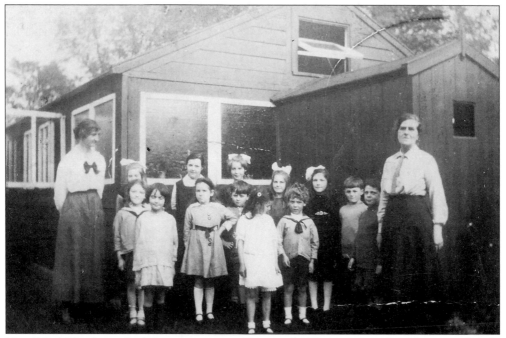

Miss Ethel Warth on the left with a group of her pupils. This private school functioned in St Martins Lane before moving to Westwood House in Park Street.

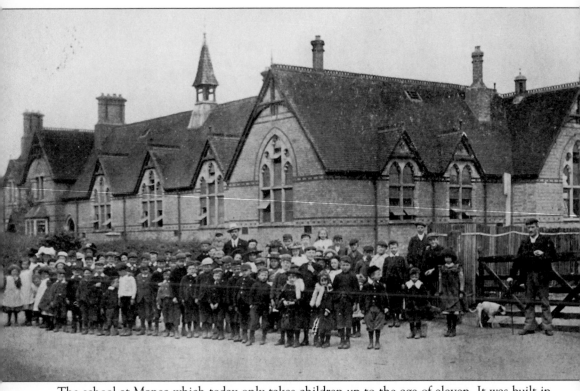

The school at Manea which today only takes children up to the age of eleven. It was built in 1876 by a private gentleman, at a cost of £2,000 and catered for up to 225 pupils.

Four

War

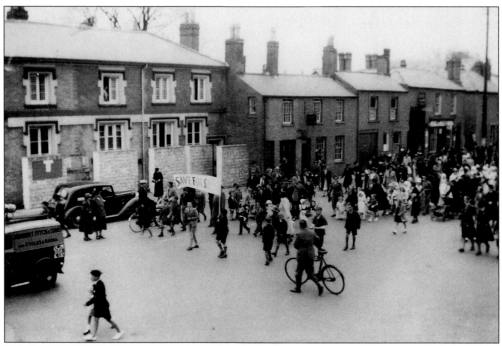

The Second World War is over and people thronged the streets to celebrate. The police station was protected against bomb damage by blast walls.

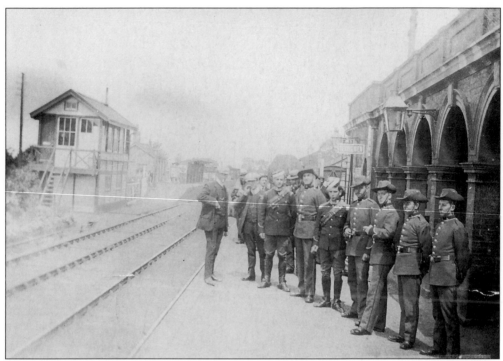

A group of Chatteris men from the local yeomanry prepare to leave Chatteris to travel to Huntingdon to act as a guard of honour for the King on 30 June 1906.

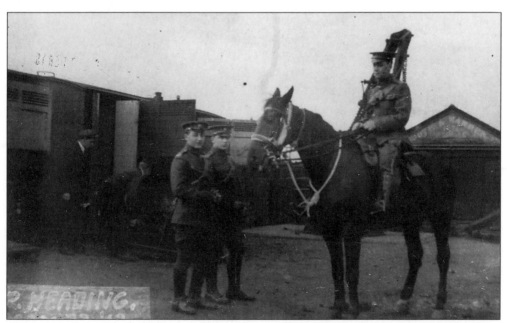

Chatteris railway station, 1912. Percy Heading (mounted), Reg Hosken and Jack Curtis of the volunteer Bedfordshire Yeomanry prepare to entrain for Godmanchester en route for camp at Brighton.

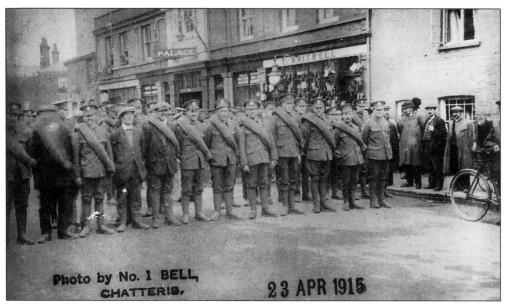

Photo by No. 1 BELL, CHATTERIS. 23 APR 1915

Chatteris volunteers in April 1915. Their cap badge indicates the Suffolk Regiment, men joining up and wishing to have an early crack at the Boche would enlist in the regular army battalions of either the Suffolks, Bedfords, Norfolks or Northants. The Cambridgeshire Territorial Regiment was initially to be used for home defence only, although they soon volunteered for foreign active service.

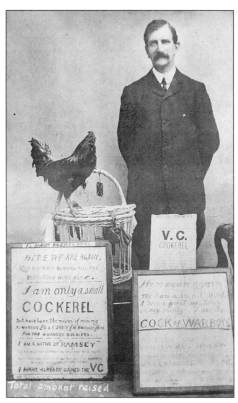

The Warboys cockerel visits Chatteris. The bird was originally given as a good luck gift when a Mr Huggins purchased a number of birds from Berry Brothers in Ramsey. It was then sold in an auction to raise money for sick and wounded soldiers realising the price of £6 0s 5d. The idea caught on and the new owner then auctioned it in Earith for £10 and at Huntingdon, the bird was sold fifty-four times raising a total of £15 18s 6d. A total of £272 was raised between November and 31 December 1915. The bird was auctioned in Chatteris on the 11 January 1916 but the amount raised is not known, however, the total Chatteris figure combined with a Red Cross sale was £200. The eventual fate of the chicken is unknown.

Chatteris soldiers. Lance Corporal Charles Hills of the Eleventh (The Cambridge) Battalion, Suffolk Regiment killed in action on the first day of the Battle of the Somme, 1 July 1916. The battalion went into action at 7.30a.m. with about 800 men, within two hours fifteen officers and 512 men were either killed or wounded. The survivors had to endure machine gun fire during the rest of the day until darkness allowed them to return to their original trenches.

Lance Corporal Horace Hills of the Seventh Battalion, Suffolk Regiment, wounded and taken prisoner in 1918.

The soldier on the right is George William 'Donkey' Clare of the Fifth Lancers. In November 1917 he was awarded the Victoria Cross, the official citation reads: 'For most conspicuous bravery and devotion to duty when acting as stretcher bearer during a most intense and continuous enemy bombardment, Clare applied field first aid dressings to their wounds and escorted them over open ground instead of using the trenches. At one period, when all the garrison of a detached post, which was lying in the open about 150 yards to the left of the line occupied, had become casualties, he crossed the intervening space, which was continually swept by heavy rifle and machine gun fire and, having dressed all the cases, manned the post single handed till a relief could be sent. Clare then carried a seriously wounded man through intense fire to cover and later succeeded in getting him to the dressing station. At the dressing station he was told that the enemy was using gas shells to a large extent in the valley below and as the wind was blowing the gas towards the line of trenches and shell holes occupied, he started on the right of the line and personally warned every Company Post of the danger, the whole time under shell and rifle fire'. A dressing station was a position just behind the front line and manned by medical staff to apply first aid dressings to a soldier's wounds prior to evacuation. Later on the same day, 29 November, he was killed by a shell. His name is commemorated within a stained glass window in the church and in the renaming of Anchor Street to Clare Street. The new surgery in New Road is also named after him.

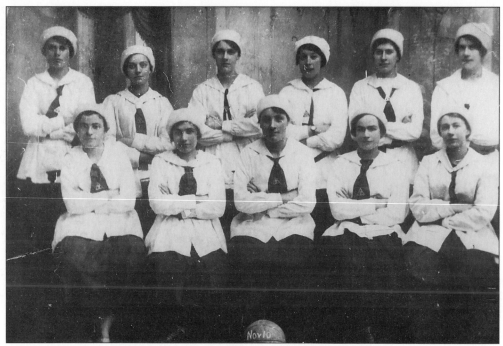

The women's football team from Chatteris Engineering Works in November 1917. The factory produced artillery shells of both small and large calibre for the Ministry of Munitions.

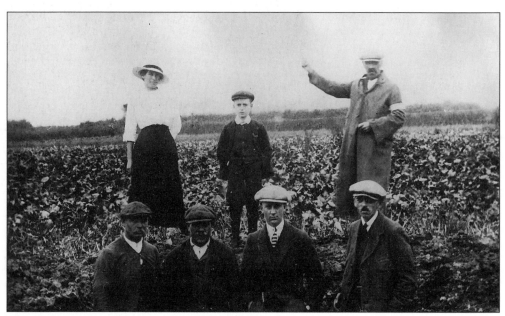

The Germans visit Chatteris. A passing Zeppelin dropped a high explosive bomb in Horsley Fen near Stocking Drove. Mr Allen is holding up a fragment of the bomb.

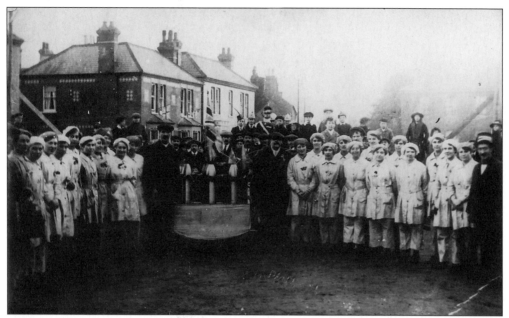

Celebrations for peace in 1918. Munition workers pose in East Park Street. In the background an effigy of the Kaiser awaits its fate on the bonfire.

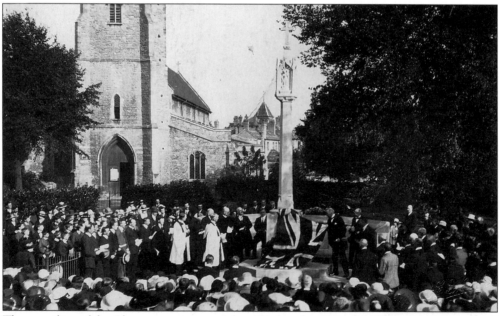

The unveiling of the Chatteris war memorial on Wednesday 6 October 1920. One hundred and fifty-eight names are inscribed of those who fell in the Great War.

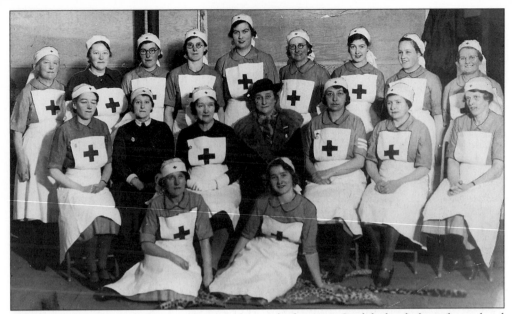

The Red Cross was very active in Chatteris during the last war. Qualified to help with any local emergency, many members also helped the nursing staff at Doddington hospital. The Masonic Hall in Huntingdon Road was requisitioned for residents from a bombed out old peoples home in London and the Red Cross manned it.

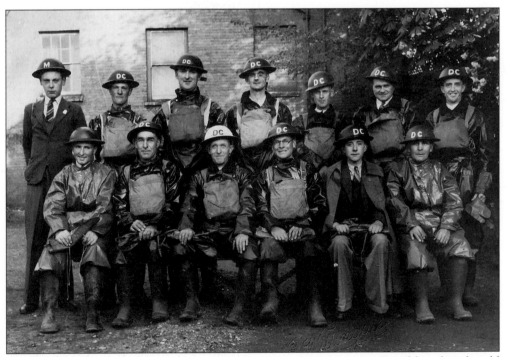

Air raid precautions, members of the Chatteris Gas Decontamination Squad based at the old New Road girls school in 1940.

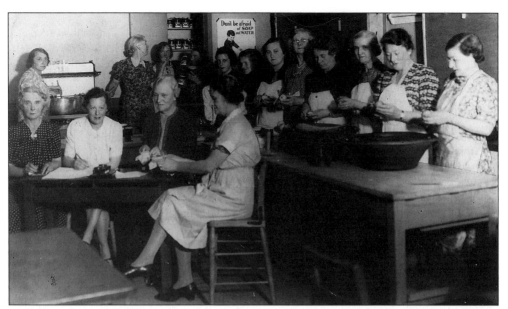

The Chatteris branch of the Womens' Institute was formed in 1927. By the 1940s, it had four hundred members and a waiting list. The ladies performed sterling work during the war. This photograph shows a group preparing fruit for jam which was sold in the local shops. They also had canning sessions, and provided a rota to cook and serve the meals at the Red Cross centre which opened in the Masonic Hall.

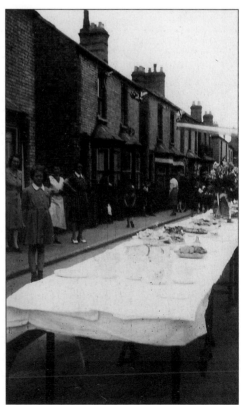

When peace was declared after the Second World War, there were celebrations and a few streets held a party. This is York Road, a quiet cul-de-sac, very suitable for such a function.

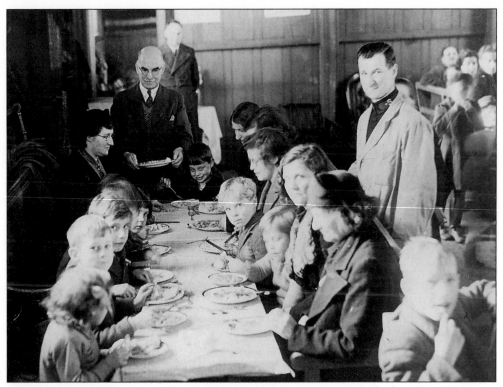

As soon as war broke out in 1939, evacuees were sent from London to East Anglia. The first to arrive in Chatteris were fed in the 'Friends Meeting House' in the High Street. Helpers are Mr H. Near, a local businessman and Salvation Army Officer.

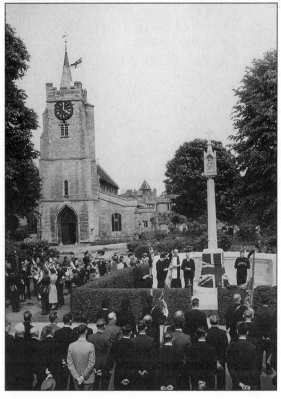

A second unveiling ceremony at the war memorial. The names of those lost in the Second World War were added to the base of the cross.

Five

Churches

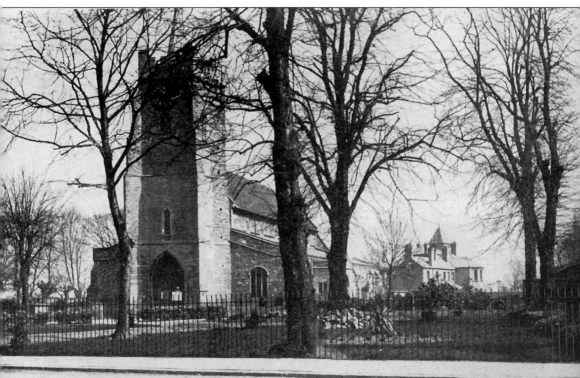

St Peters church. A photograph taken before the railings were removed to make room for the
First World War memorial. Behind the church is the second vicarage, now a private residence.

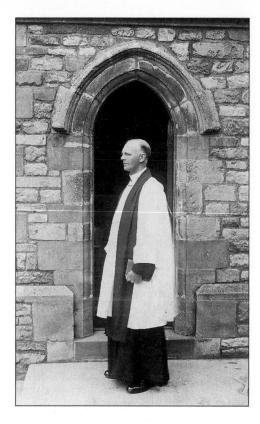

The Revd H.F. Bagshaw, vicar of Chatteris, whose son was killed in the First World War.

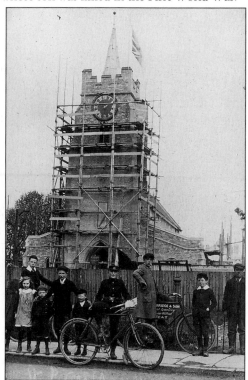

The church was extensively repaired and renovated in 1910. Note the *Telegraph* boy and the butchers' errand boy.

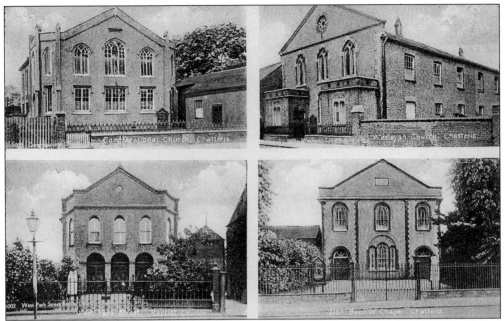

The Congregational church dates from 1838. Now renamed Emmanuel church, it has been modernised and is used by the congregations of the Methodist church and the West Street Baptists. The Wesleyan Methodist Church in New Road was built in 1815. Now demolished, the site was used for a cold store and more recently a surgery and a nursing home. West Park Street Baptist Church was built in 1835 at a cost of £800 and is now used as a furniture storeroom. Zion Baptist Church was founded in 1819. The church has closed and the building is now being adapted for commercial use.

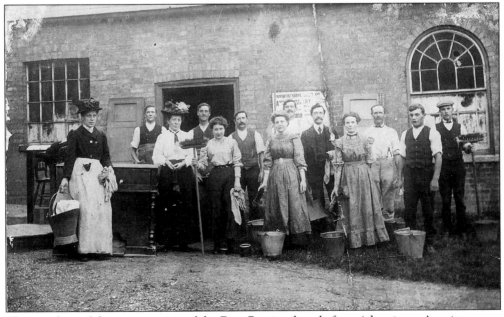

The members of the congregation of the Zion Baptist chapel after a 'cleaning-up' session.

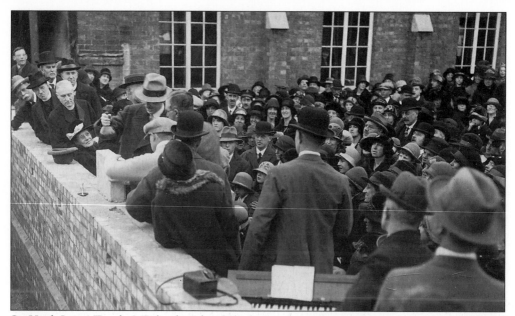

Sir Hugh Lucas Tooth, MP for the Isle of Ely, laying the stone to commemorate the building of the schoolroom by the side of the Congregational church, East Park Street, 1925.

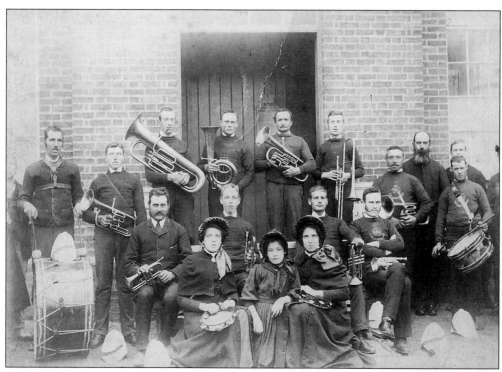

Members of the Salvation Army with their band outside their citadel in East Park Street.

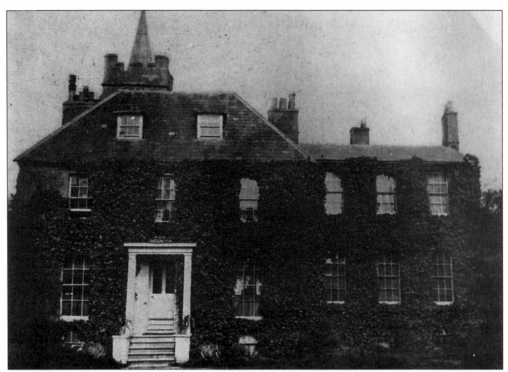

Standing to the front of the Parish church on the possible site of the medieval market place was the original 'old' vicarage. The house was destroyed by fire in the 1880s, the steps to the front survived and were incorporated into a new house in South Park Street. This too was destroyed by fire in the 1990s, however, the steps still remain.

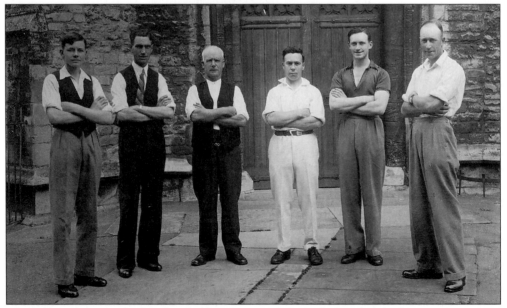

The bell ringers outside the church of St Peter and St Paul after they had rung a coronation peal, 12 May 1937. They were R. Paul, S. Murphy, A. Abrahams, W. Young, D. Paul and W. Seekings.

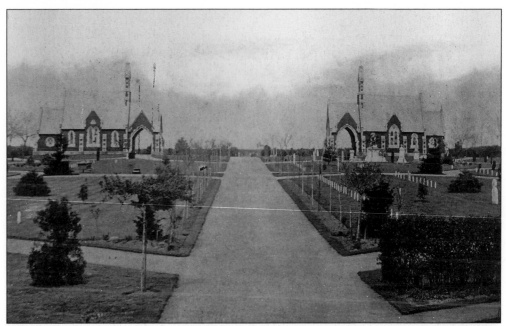

An interesting picture of the second cemetery in New Road which was opened in 1869. The avenue of trees had just been planted and in the background are the two chapels which were built for funeral services, these were demolished some years ago.

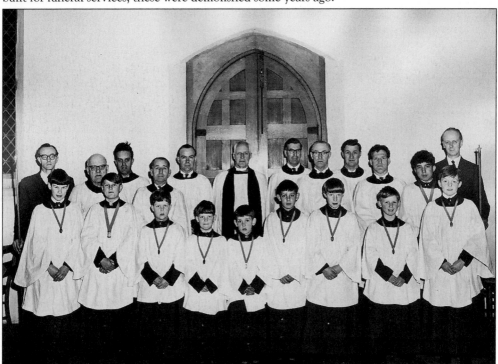

This picture, taken in 1966, was the first time the choir had been photographed since 1903 and the first time anyone could remember when they were completely re-robed. The new cassocks were blue instead of black. The vicar is the Revd J. Hawthorne.

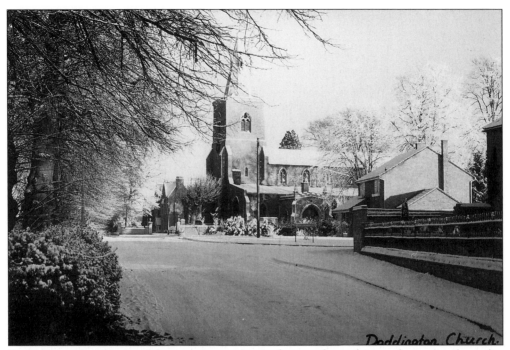

Doddington church, one of the most interesting in the area, has a thirteenth century chancel, a fourteenth century nave and tower and fifteenth century windows in the chancel.

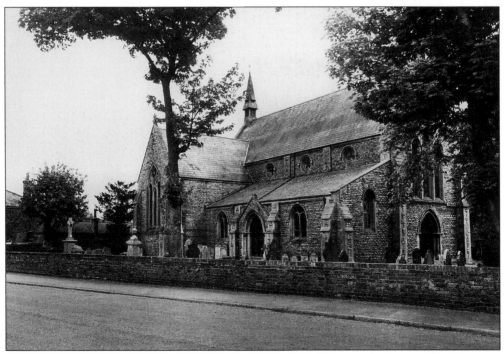

The church at Manea, built in 1875 at a cost of £400 seated 350 people.

The Mission Tent, 1916. This tent was given to the father of Silvester Gordon Boswell when the Gypsy Mission in Manchester finished with it. The Boswell family travelled round the country with it and finally came to Turf Fen, common land between Chatteris and Doddington, they stayed for four years holding regular services when either Mr or Mrs Boswell would preach and their daughter Laura played the harmonium. The gypsies living in the caravans attended the services and, on occasions, as shown in the photograph, people from Chatteris were invited to join in. Mr and Mrs Boswell were paid for their mission work, a cheque for about £8 arriving each month from the Free Trade Hall at Manchester, but they also relied on collections to keep the tent in repair, buy coke and paraffin oil for heating and lighting.

Six
Events

This old building was originally the Corn Exchange. The ceiling was lowered when it was brought and converted into the Palace cinema. In 1938 it changed hands again to become the 'Palace' dance hall with the new owner Mr H. Barrett building cloakrooms, a kitchen and a dance area with a splendid oak floor.

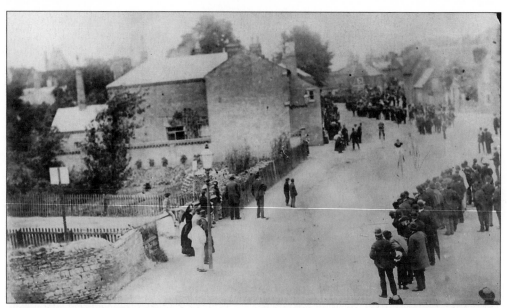

A bicycle race passing through East Park Street. The machines are 'ordinary bicycles' now more commonly referred to as 'penny farthings'. The Salvation Army citadel is still to be built on the corner of the private road soon to become Victoria Street.

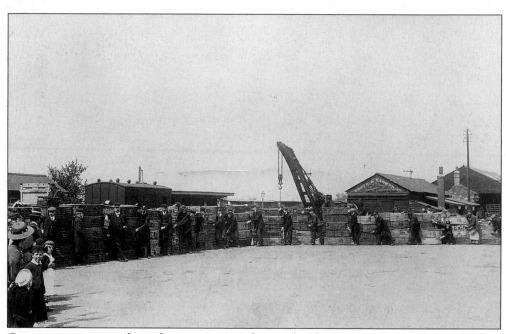

Great excitement at the railway station as thousands of racing pigeons are about to be released.

In 1911 a pageant was organised in the town depicting its past history. Two of the people in the group are Mike Williams and his wife, who ran the cinema, 'The Palace', on Market Hill. The gentleman on the left is Mr Hammerton, a member of a well-known Chatteris family.

When concert parties were popular at seaside resorts, Mr E.C. Sutherall (Barclay's bank manager) formed the 'Rainbows' in Chatteris and they toured East Anglia giving concerts for various charities. Back row, left to right: Miss Bridgemont, Mr E.C. Sutherall, Mrs Sutherall (pianist), Mr Spencer Graham, Miss D. Ruston. Front row: Miss A. Weedon, Mr Algy Graham, Miss G. Freeman.

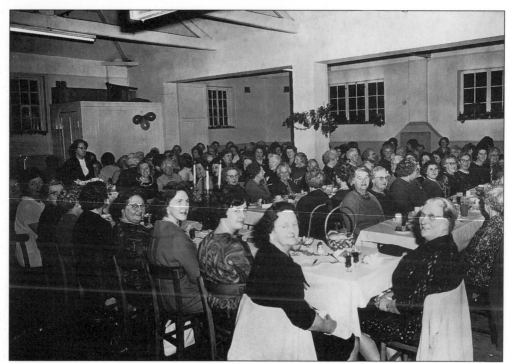

The local Women's Institute celebrating the Golden Jubilee of the W.I. movement. This is the parish room (church hall) in Church Lane where they held their monthly meetings until it was demolished and the land used as a car park.

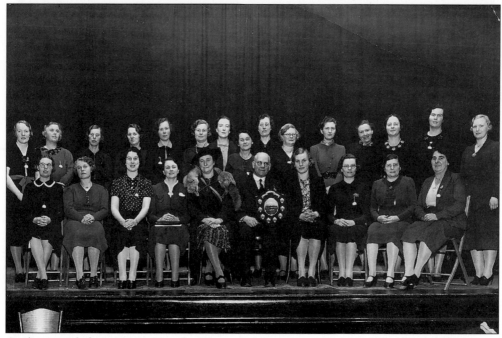

At the annual choir competition for Women's Institutes in the Isle of Ely, the shield was won by Chatteris in 1937. The choirmaster was Charles Sinden.

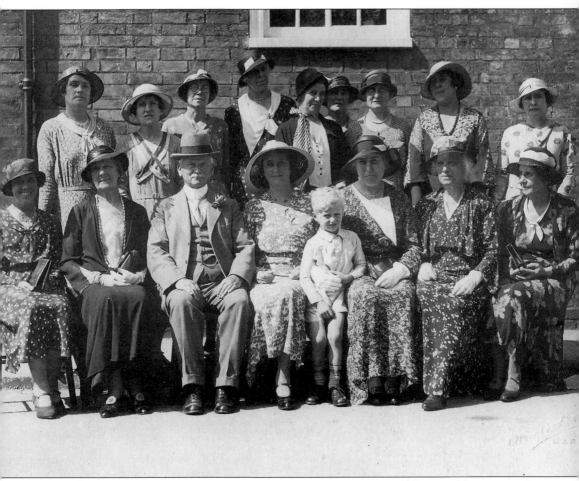

A branch of the W.I. was opened in Chatteris in 1927. This photograph was taken at one of their first flower shows, and we see officers and members of the committee. The gentleman is Mr A.J. Kidd, who was a judge, and sitting on his right is Mrs Nix, the wife of the local doctor.

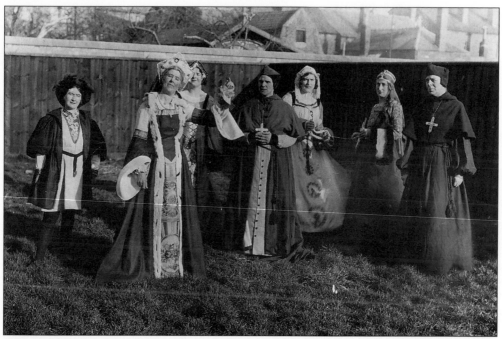

Most Women's Institutes had a drama team, and Chatteris was no exception. They regularly entered a team in the annual Drama Festival, and in this particular year in the 1930s, the set piece was a scene from one of Shakespeare's plays.

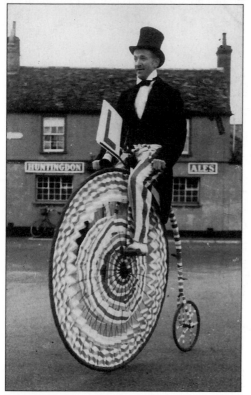

George Burkett, the owner of this penny farthing, was always ready to dress up and attend any local function raising money for charity. The bicycle is now in Chatteris museum.

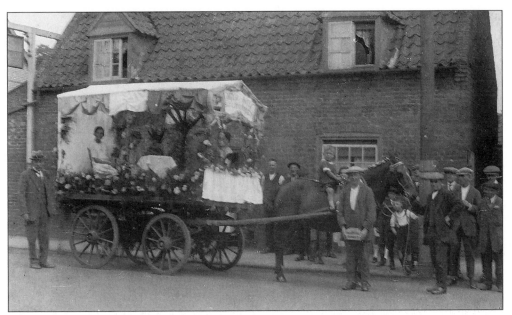

One of the floats at an early Hospital Sunday.

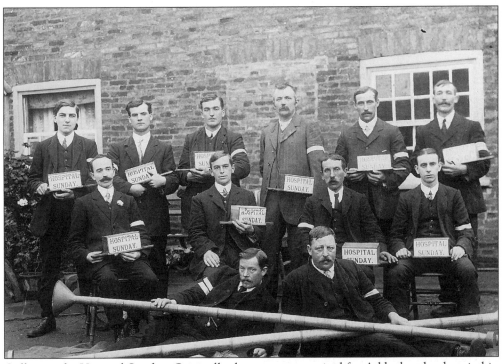

Collectors for Hospital Sunday. Originally the money was raised for Addenbrookes hospital in Cambridge but later contributions were made to Doddington hospital. The bamboo poles were used to collect donations from people watching from upper floor windows as the procession of floats and marching bands proceeded through the town.

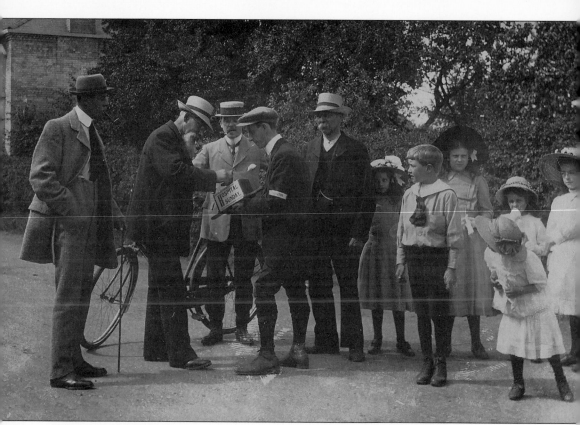

Collecting in Station Street at one of the early Hospital Sundays. The children are obviously in their Sunday best!

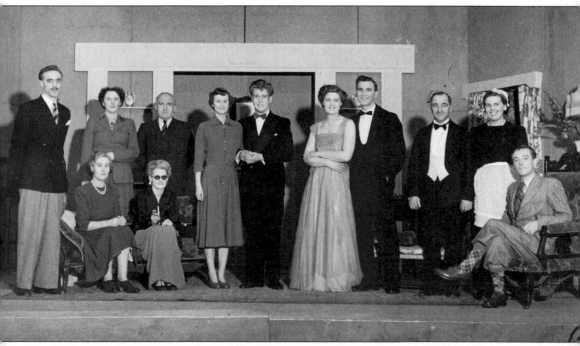

The Evening Institute Drama Class performed a three-act play at the end of the winter session. This is the cast of the production of *Random Harvest*, by James Hilton, performed in 1953.

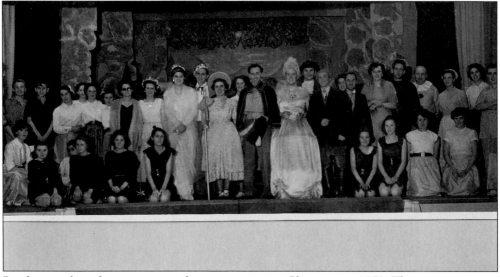

Breaking with tradition, an extra show was put on at Christmas in 1952. The pantomime was *Boy Blue*.

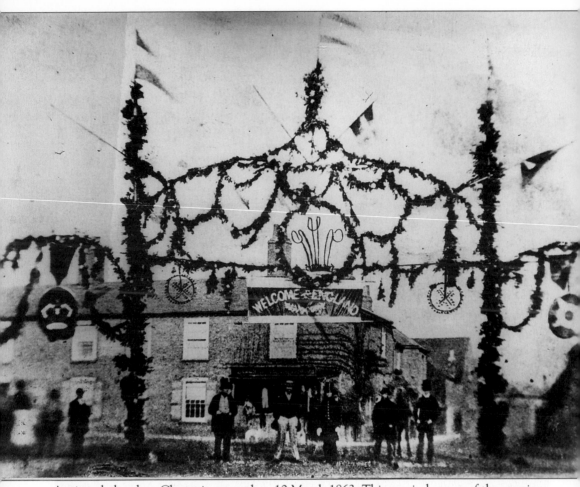

A triumphal arch at Chatteris, erected on 10 March 1863. This was in honour of the marriage of HRH The Prince of Wales. The centre arch was over thirty feet tall with a span of twenty-eight feet and lit by five hundred gaslights.

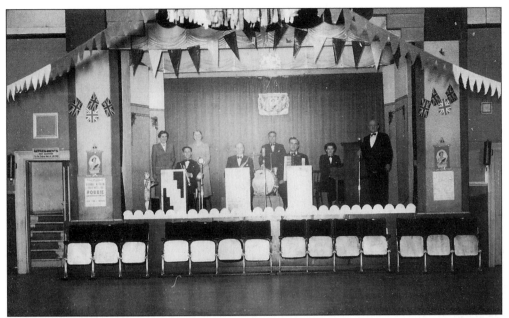

The Palace, bedecked with flags, ready for celebrating the coronation of Queen Elizabeth II. The old blue plush cinema seats were still in use.

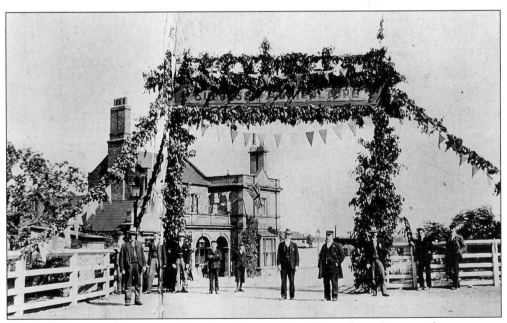

An excellent view of the approach to the railway station. The archway banner refers to success in agriculture.

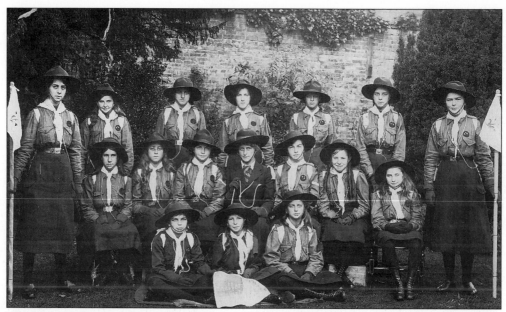

The first Girl Guide company was formed in Chatteris before the First World War. The officer in charge was Miss H. Richardson (later Mrs Bruce Francis). Drill was taken by an old soldier, with wooden rifles which were kept in their meeting place the old Parish Room, sometimes known as the Church Hall. Many of the girls were from well-known Chatteris families such as Weedon, Porter, Angell, Fryer, Hipwell, Adcock, Fitch, Heading, Ruston, Kemp.

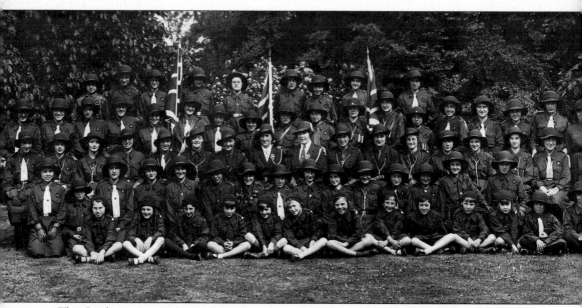

The Guide movement was reformed in the early 1930s by Mrs H. Barrett who became district commissioner. This group was taken in the vicarage garden after the dedication of their new colours. Three Guide companies and two Brownie packs are with their officers and the Hon Mrs de Beaumont, county commissioner.

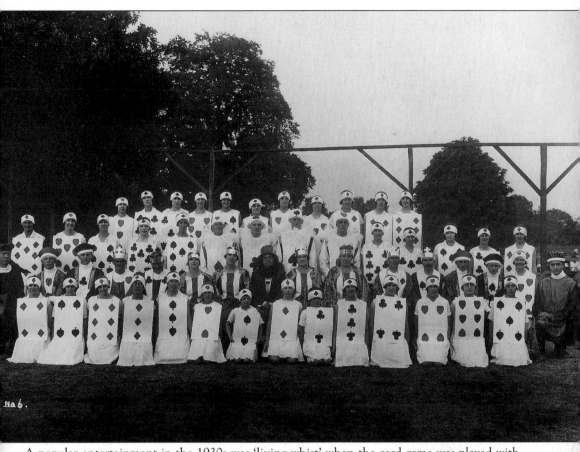

A popular entertainment in the 1930s was 'living whist' when the card game was played with people dressed as the various cards.

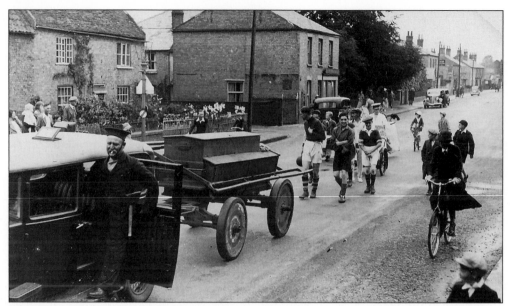

This is the first fire engine owned by Manea, pictured here in the 1920s. It was nicknamed 'Tilley' and was purchased after a spate of fire raisers had caused havoc in the village. On 22 December 1830 a meeting was held and the matter was discussed, but it was not until 1844 that a penny levy raised the £140 to buy this engine. Years later, having been abandoned and in a derelict condition, it was rescued and sent to the Fire Service College in Moreton in the Marsh to be restored. It can now be seen in the fire station.

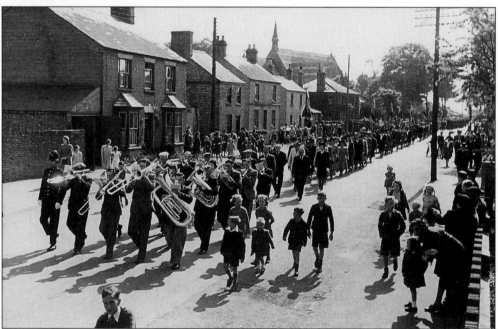

Manea has for many years been proud of its band. Formed in 1882, it was one of the best in Cambridgeshire for years and won the top prize at Crystal Palace in 1924. This picture was taken some fifty years ago when it paraded for the Dedication of the Standard for the Womens' Section of the British Legion.

Seven
People and Work

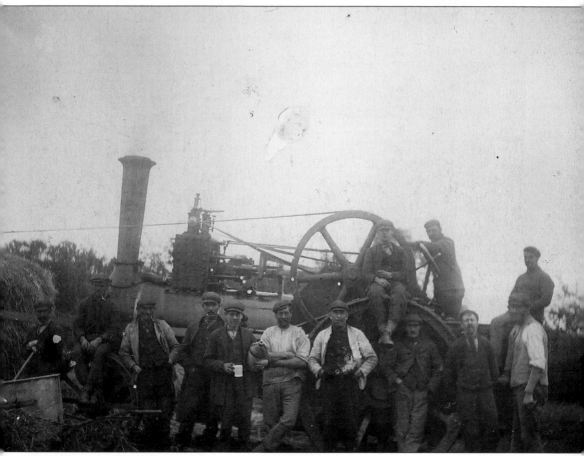

A well known threshing crew with one of Jeremiah Carley's compound engines at Newgate, Doddington in 1910. Such characters as Long George and Cockney George were among the crew.

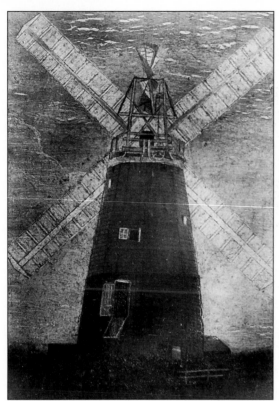

There were five mills operating in Chatteris at the turn of the nineteenth century, but Black Mill, owned by William Warth of Seymour House, and the nearby White Mill live on in street names.

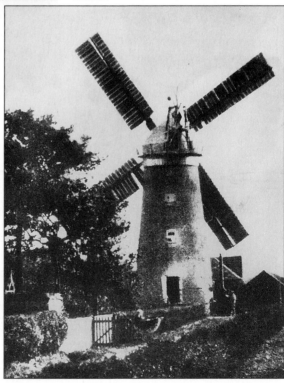

Bensley's mill situated towards the end of New Road.

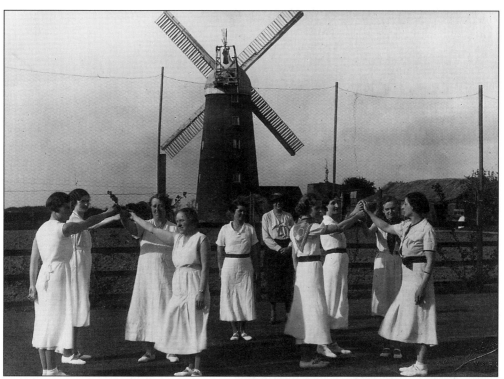

Country dancing in front of the mill in Doddington in the 1930s. Although the area has been developed the bottom half of the mill still stands.

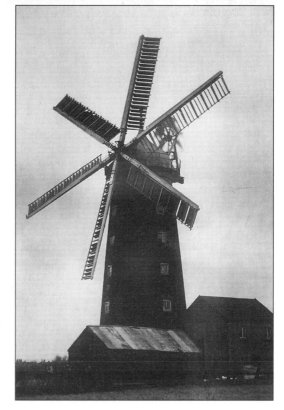

The windmill belonging to Mr Edwards in Station Road Manea where Mr Whymark ground wheat for flour, and wheat and barley for the cattle and horses. It was a rare design with six sails and was demolished in the early 1930s.

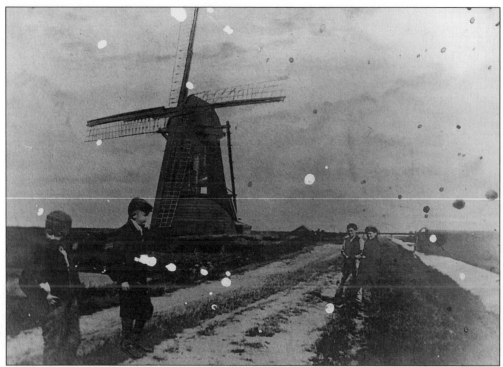

Bulls Pump on the Forty Foot River near the Chatteris Docks with the railway bridge just visible in the background. By the middle of the nineteenth century most of the major wind pumps had been replaced by steam engines capable of removing far greater quantities of water and therefore contributing to further fen shrinkage.

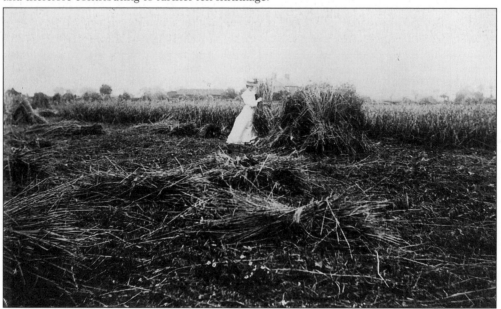

Before the day of the combine-harvester, when the corn was cut by scythes, tied into bundles (sheaves), several of which were propped together to form a shock or stook. The air could blow through and dry off the corn before it was loaded on a cart to be taken to a threshing yard.

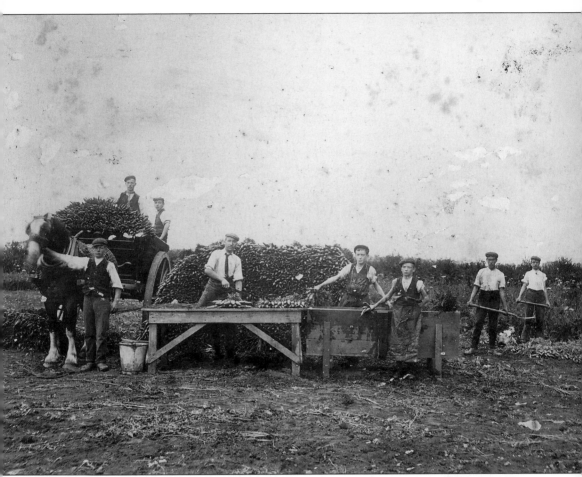

When carrots became an important cash crop, fenland farmers found it was an ideal vegetable to grow on the rich, fertile soil. Many people were employed as carrots were hand-sown, thinned and harvested by men and boys who had cycled or walked out to the fields with their 'dockey' - a mid-morning meal.

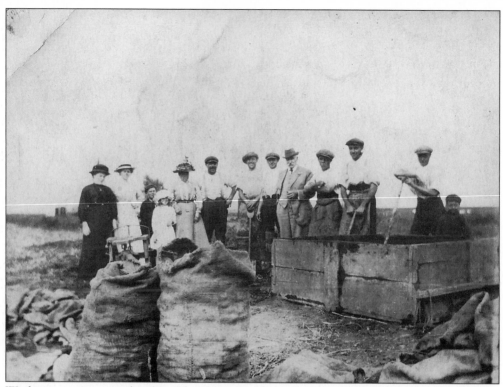

Washing potatoes in the fen. The farmer and family have joined the labourers for the photograph.

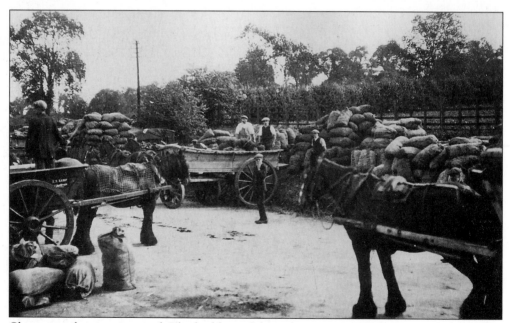

Chatteris railway station yard. The building of the railway in 1848 and in particular, the poor harvests during the 1870s combined with cheap imported grain from the USA, saw many farmers turn to cash crops such as carrots and potatoes to supply the London markets.

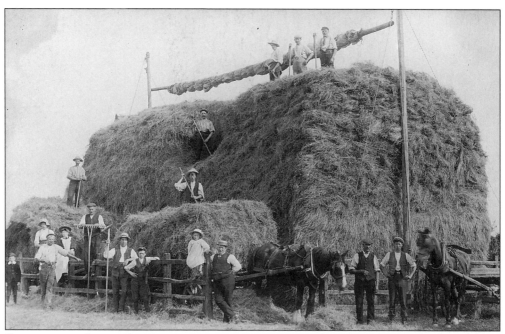

Constructing a hay stack.

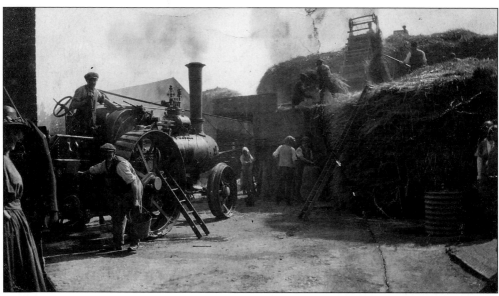

A typical scene of threshing in a Chatteris stack yard. All around the edge of the town, particularly in Slade End and Hive End, farmers maintained stack yards and labourers cottages. Their own houses tended to be situated in the more fashionable parts of the town. This unusual pattern of farm development was caused by the difficulty of building traditional farms on the unstable fen soil.

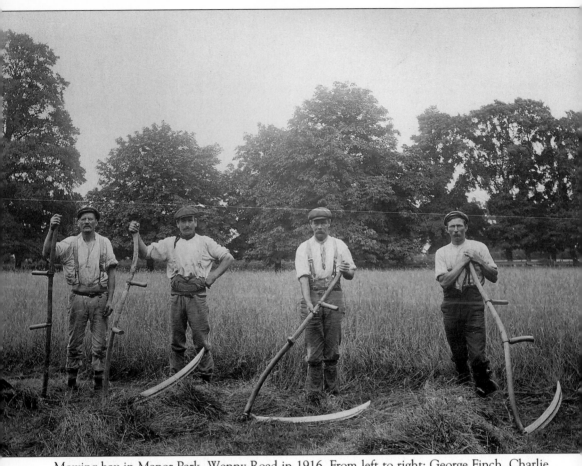

Mowing hay in Manor Park, Wenny Road in 1916. From left to right: George Finch, Charlie Smith, Jim Sneesby and George Bedford.

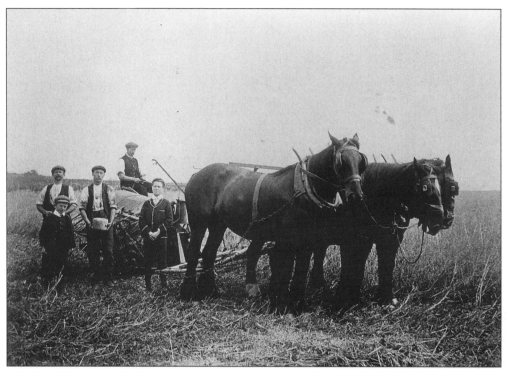

A farm labourer's meal in the field traditionally consisted of cold unsweetened tea (beer on occasions), bread and cheese. The size of this cheese would indicate a gift for the harvest home, a celebratory festival when all the crop had been gathered.

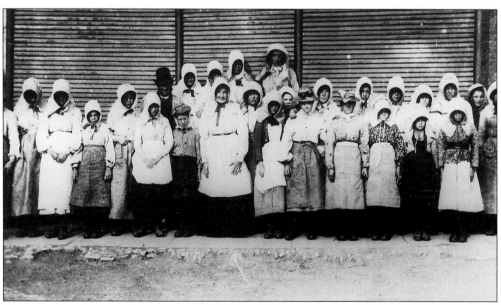

An agricultural gang of women and children. The gang system developed soon after the enclosure of the common land during the first years of the nineteenth century.

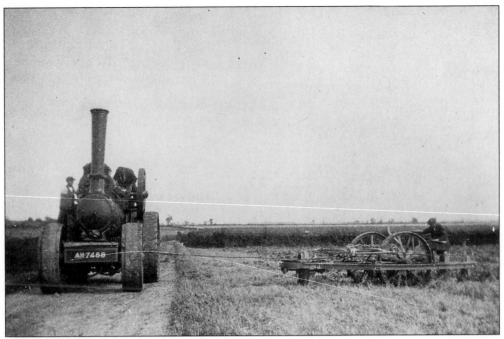

Carley's engines steam ploughing on Tithe Farm, Chatteris. The plough was winched between two engines by a cable and drum.

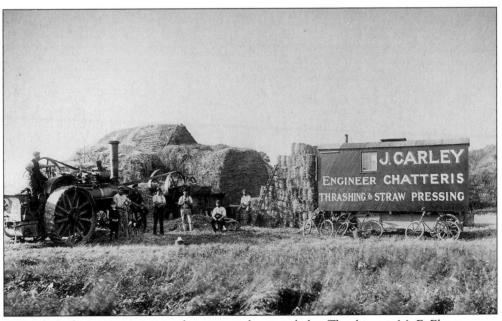

Jeremiah Carley's crew pressing either straw or hay into bales. The driver is Mr E. Elmer.

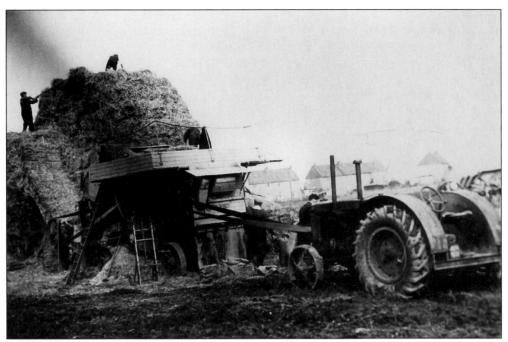

Harvesting in Manea. This photograph shows the traditional traction engine with threshing tackle using a tractor to provide power to the belt drive. The lower picture is of the first combine harvesters to be used in Manea.

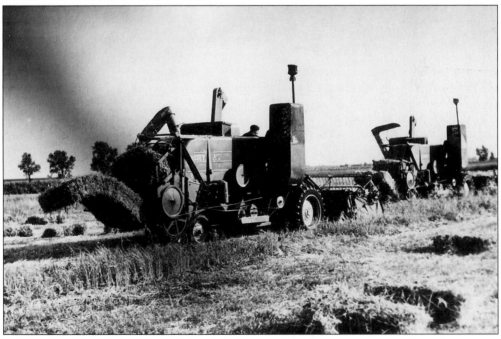

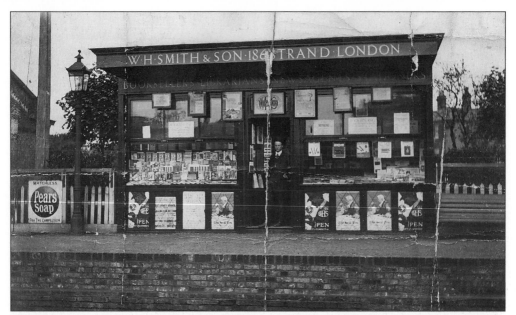

W.H. Smith's bookstall situated on the platform of Chatteris station. Beside selling newspapers, stationary and chocolate, there was a flourishing library. If a book was required urgently, the order could be 'telephoned through to head office' and put on a train, and so delivered on the same day. Unfortunately after the war when the station closed, the business was sold and moved to a shop in Station Street which eventually closed.

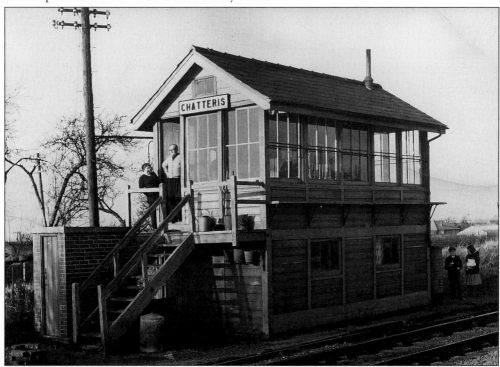

Will and Maggie Thorn, signal man and crossing gate keeper at Chatteris railway station. This photograph was taken near to the time of closure in 1967.

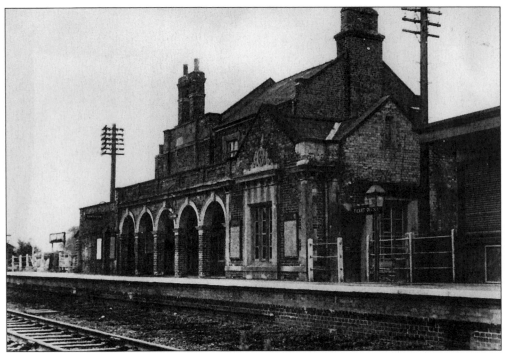

The Victorian railway station, built in front of the stationmasters house. W.H. Smith's bookstall is on the right.

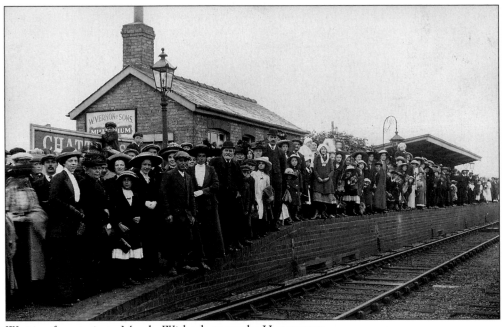

Waiting for a train to March, Wisbech or maybe Hunstanton.

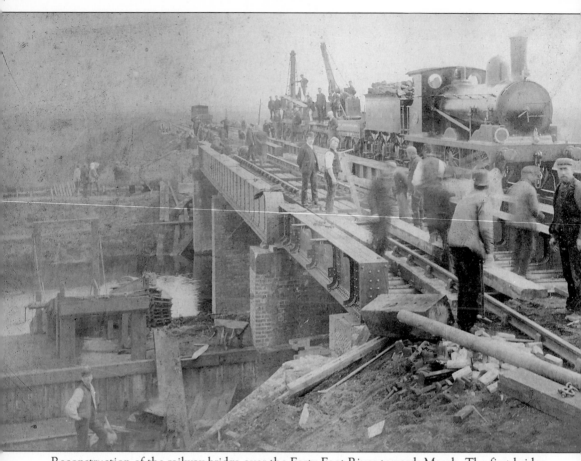

Reconstruction of the railway bridge over the Forty Foot River towards March. The first bridge was completed in February 1848 and rebuilt in 1863. The iron and brick bridge of 1900 replaced an earlier wooden trestle style. The line was formerly closed on 6 March 1967.

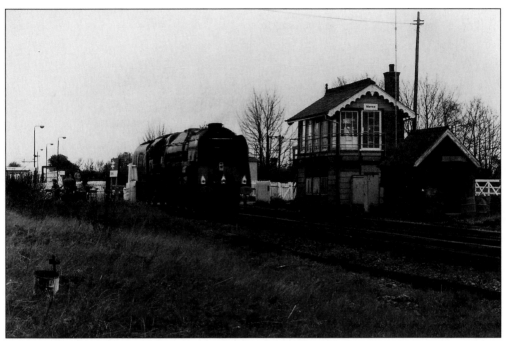

Manea station on the Kings Lynn to London line remains in use.

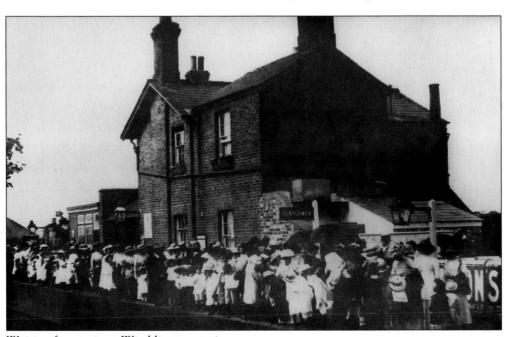

Waiting for a train at Wimblington station.

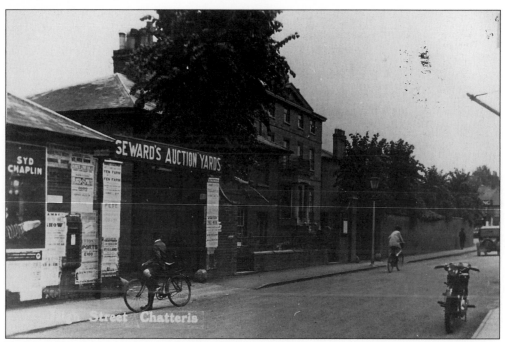

Frederick Seward lived with his family in Chatteris House and started the weekly auctions on the premises at the end of the nineteenth century. He was succeeded by his son, Lindsey, and the business continued until his death in the 1970s. Eventually the house was sold and the auctions discontinued.

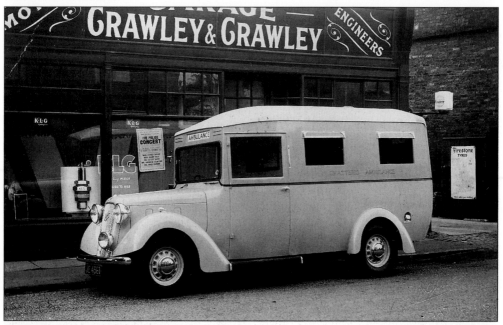

As the facilities at Addenbrookes hospital increased after the last war, it was felt that Chatteris needed its own ambulance. A committee was formed and people wishing to help donated one penny a week towards its cost. It functioned until a National Health Ambulance Service was organised to cover all areas.

Smarts Lane showing the blacksmiths shop and foundry. On 29 November 1911, the residents of the road petitioned the council to change the name to St Martins Road. In 1912 the same people again petitioned the council to take action on the activities in Church Walk, 'well known in the town for being habitually frequented by young women and young men after dark and that the indecencies perpetrated by them prohibit the use of this passage by many who would otherwise take advantage of it'.

Mr Herbert Walton and the Old Smithy at the top of St Martins Lane in 1905. A family business, they were kept busy with shoeing horses and repairing agricultural implements.

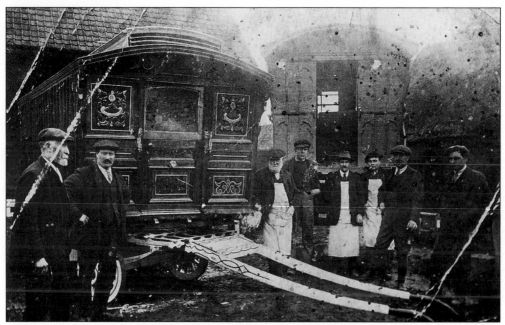

Three generations of the Waltons with caravans they were working on in 1905.

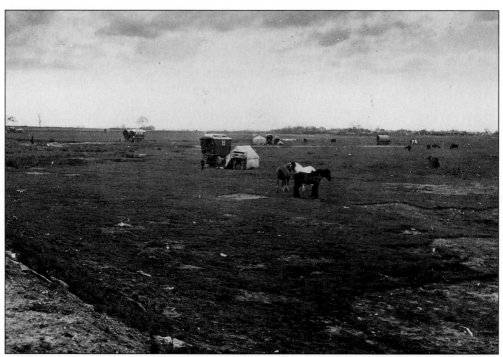

Turf Fen which was common land where gypsies could camp when seasonal work was available. On the seven hundred acres on both sides of the road, the gypsies said they could turn their horses out and forget them until it was time to move on.

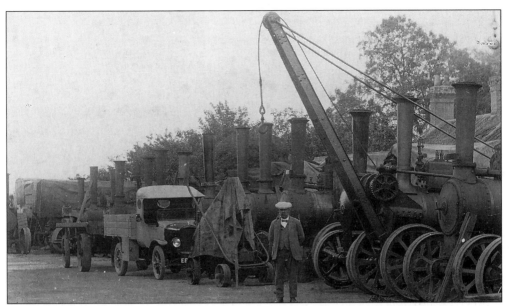

Steam engines stored in the yard at the back of the Carley's shop, No.101 High Street.

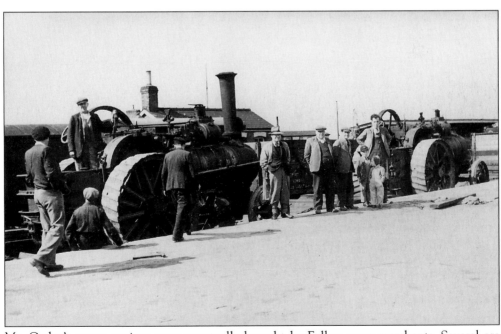

Mr. Carley's steam engines were eventually brought by Fullers scrap merchants. Several are being loaded at the railway station for their final journey.

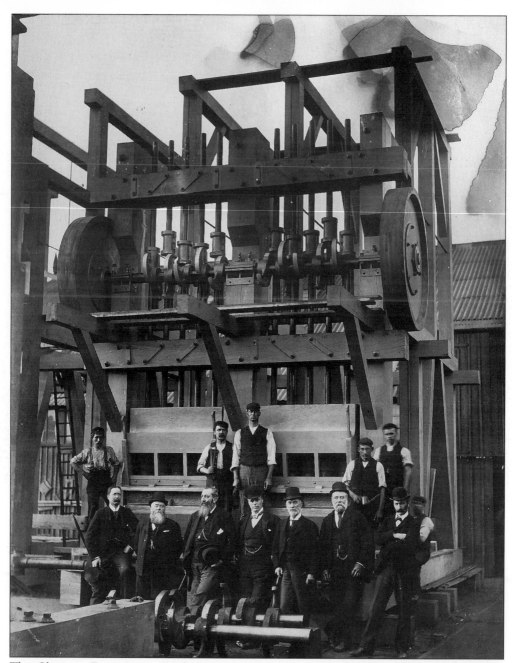

The Chatteris Engineering Works was started during the early 1890s. They specialised in making mining equipment for the South African diamond and gold mining industries around Johannesburg and Pretoria. Production was severely affected during the Boer War between 1900-2 causing the firm to consider different markets. Later they were to provide the many forms of travelling cranes found in dockyards and railway depots. The owners and workers of Chatteris Engineering Works pose for the photographer on a completed gold ore crushing machine ready for shipment to South Africa in 1895.

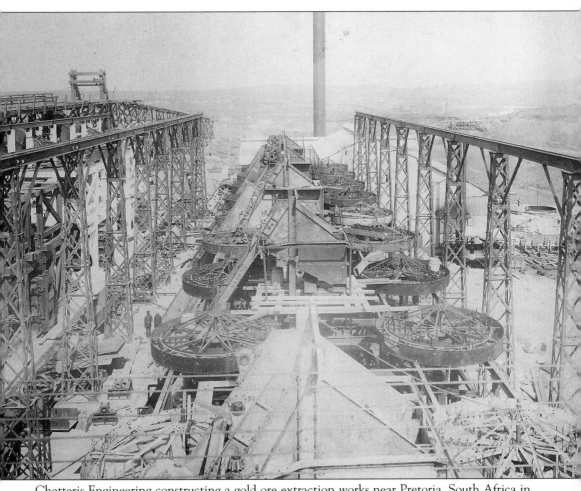

Chatteris Engineering constructing a gold ore extraction works near Pretoria, South Africa in 1902.

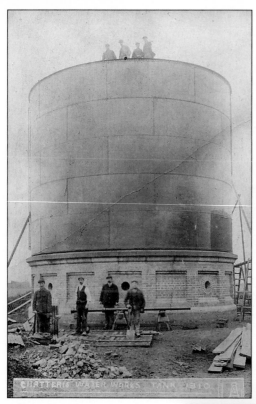

The water tower on London Road was constructed by Chatteris Engineering Works in 1910. The first pipeline to March was started in 1904, however, supplies of piped water were eventually taken from Marham in Norfolk on 1 April 1907 with a daily average of 12,766 gallons. The first complaints of summer water shortages began in 1923.

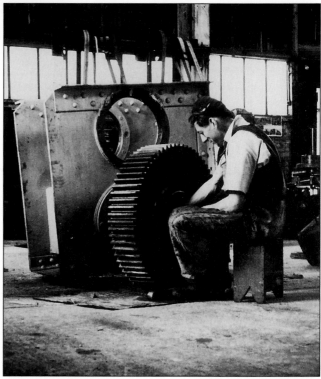

By the 1950s Chatteris Engineering Works had become Fairleede Eng Co. Ltd. Here Donald Childs puts the finishing touches to gear boxes destined for the aircraft lifts on HMS *Ark Royal* and HMS *Bulwark*.

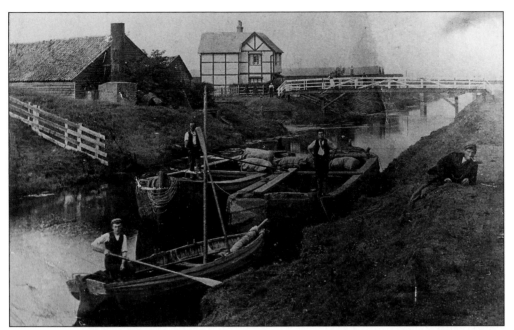

The docks in 1903. Barges operating on the waterways around Chatteris were an important and essential transport link in this area. For many years whole families were involved, the Jacksons and Stimpsons were the most well known.

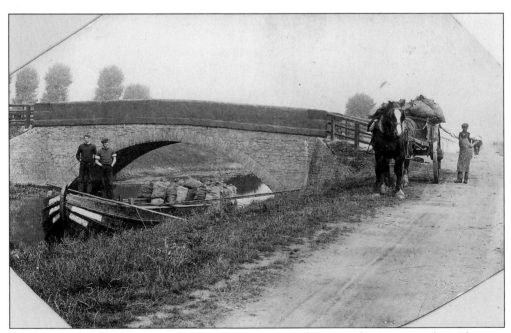

Crops are unloaded from the horse and cart onto the barges to be transported to Chatteris docks.

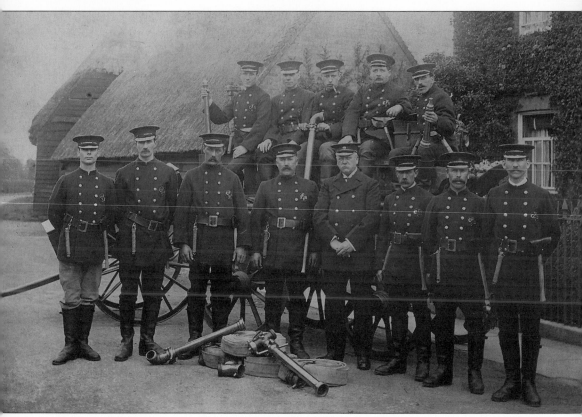

Chatteris Fire Brigade on drills in St Martins Lane. The horse drawn manual engine was one of two housed in the fire station next to the church. If a fire occurred in the town the engine was often hand drawn to the incident, horses would be commandeered from the George Hotel for fires out of the town.

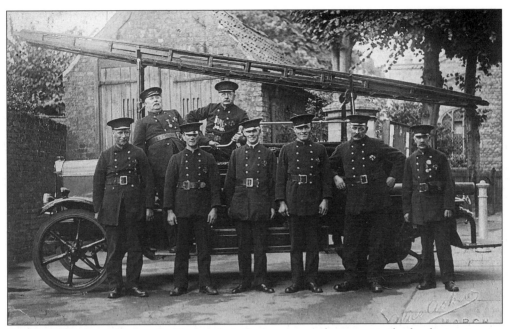

Chatteris Fire Brigade proudly display their first motor appliance, outside the fire station on Market Hill in 1928.

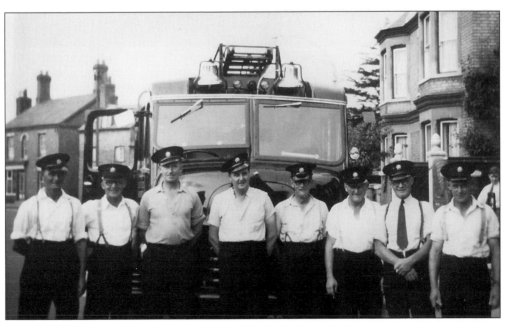

Chatteris Fire Brigade in the early 1950s. Left to right: B. Walton, B. Allen, D. Paul, J. Stukins, C. Green, C. Brown, P. Allen and E. Laws.

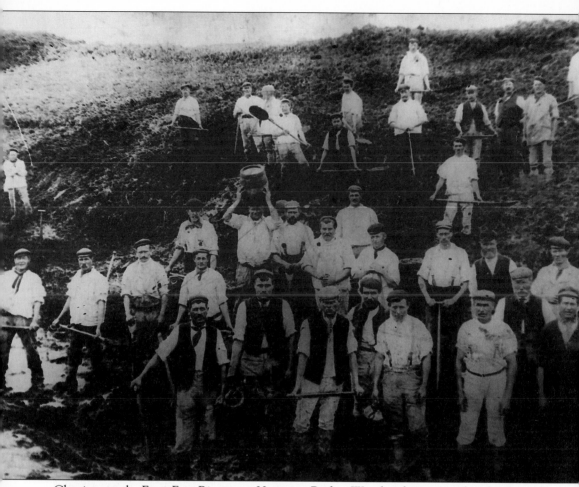

Clearing out the Forty Foot River near Horseway Bridge. Wooden dams were placed either side of the stretch to be maintained and the water pumped out, two gangs of workers would operate on opposite banks. The trapped fish were then free to all but often a selected member of each gang would fight for the spoils.

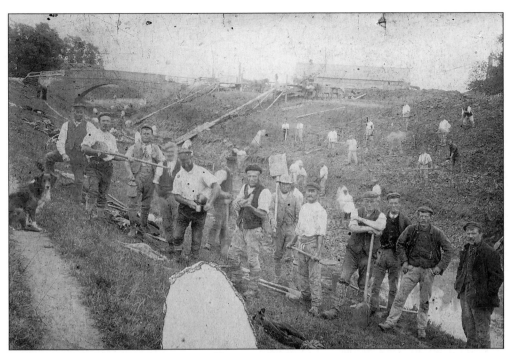

Clearing out the Forty Foot River near Horseway Bridge.

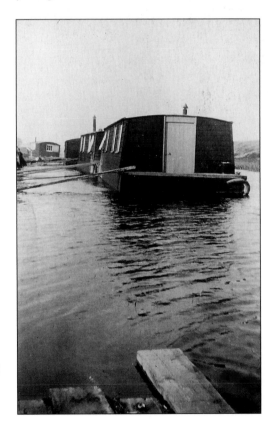

There was a lot of river traffic on the Old Bedford and other cuts. The main cargo on the barges was sugar beet, but they carried other goods like coal to the various pumping engines. This picture shows the houseboats providing accommodation for the workmen building a railway bridge.

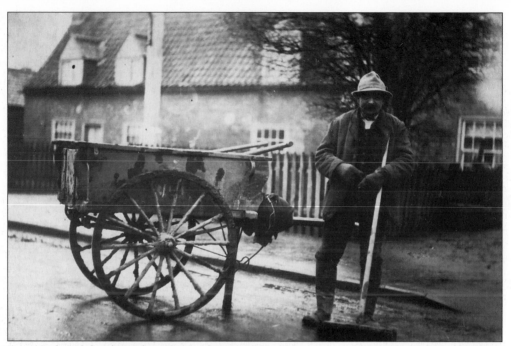

A reminder of the days when the road sweeper could be seen on his regular round in Manea. This is Mr Parsons who worked for the parish council.

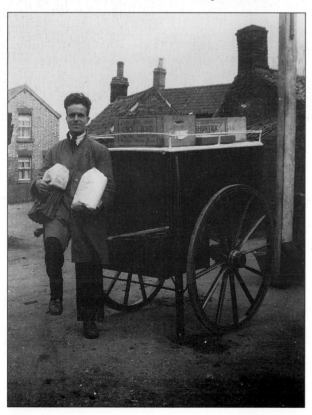

Billy Stubbs pulled his cart round Manea delivering bread, flour and groceries for the Co-op during the Second World War.

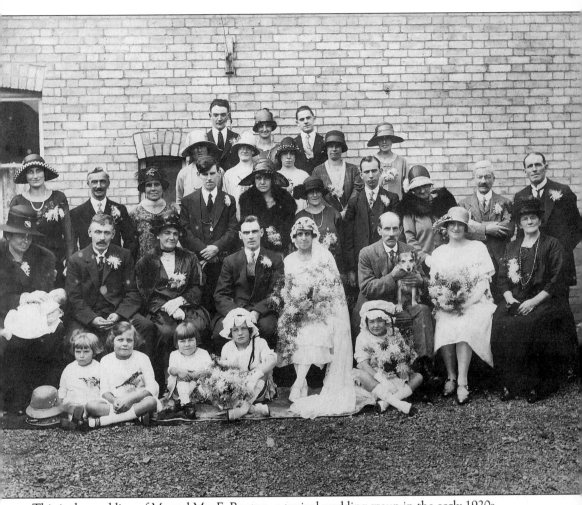

This is the wedding of Mr and Mrs F. Benton, a typical wedding group in the early 1920s.

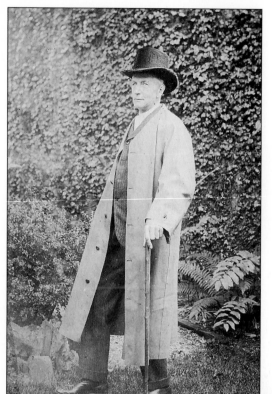

Sir William Henry Clarke was the manager of Barclays bank, Chatteris and once a week he visited Lord Peckover at Wisbech on business. The Liberal Prime Minister, Lord Roseberry, was a friend of the Peckovers and he wanted his son, the Hon Neil Primrose, to be an MP, so it was decided he would put up in this area and his agent would be William Clarke. Neil was successful, his family was delighted and William Clarke was knighted for his efforts. Unfortunately the new MP was killed in the First World War.

Mr William Noble Smith and his wife at the door of Cemetery Lodge in New Road. On his tombstone it records that he was the cemetery keeper for fifty years. Their daughter married William Brewer at the beginning of the Great War and on his safe return he joined his father's saddle and harness making business on Market Hill.

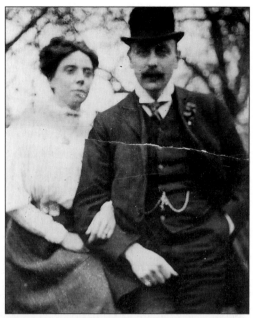

Hedley E. Dwelly, Ph.C (1868 - 1940) bought the pharmacy in Park Street from Mr Pratt in 1916. He was a great character and became well-known in the area, especially by the farmers who relied on him, in the absence of a vet, to mix the right potion to cure all sorts of ills and complaints suffered by their stock. He is pictured here with his wife, who also took an active interest in the area, helping with the W.I. and for many years as treasurer of the local association of the Girl Guides.

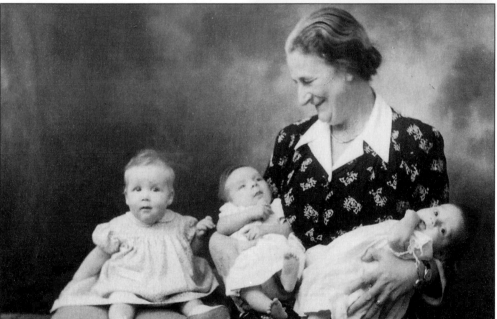

Alderman Mrs F.A. Barrett, a well-known Chatteris resident for many years. Always interested in town affairs, she was the first lady councillor on the Urban District Council. Later on as a member of the Isle of Ely County Council, she was the first and only lady alderman in the Isle, an honour which no longer exists. She was instrumental in starting many organisations in Chatteris, the W.I., Red Cross, Girl Guides, a founder-member of the Mothers' Union, a National Savings Branch, Good Companions and during the war the W.V.S. She was a governor of all the local schools and also the March High School and the Wisbech College for Further Education. The photograph shows Mrs Barrett with her first three grandchildren, all born within six months just after the Second World War.

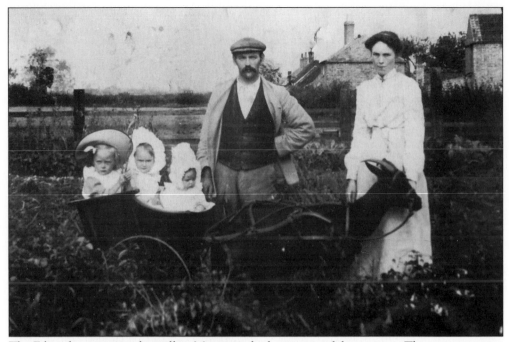

The Edwards, operating the mill in Manea at the beginning of the century. The goat cart must have been a good substitute for the pram, not only would it hold more, but would be easier to cover rough ground. Note the lovely headgear of the children.

People from all the surrounding villages came into Chatteris for the 'fair'. This was held in the main street and one of the most popular stalls was Rocky Thompson's. All kinds of rock and nougat could be brought. This picture, taken in 1948, is of Mrs Yeada Smith, the Rock Queen, seated on the steps of her caravan parked in the yard at the King William IV public house. The little girl is Phyllis Stacey whose grandparents kept the pub. One of the copper preserving pans used for making the rock is now in the museum in Chatteris.

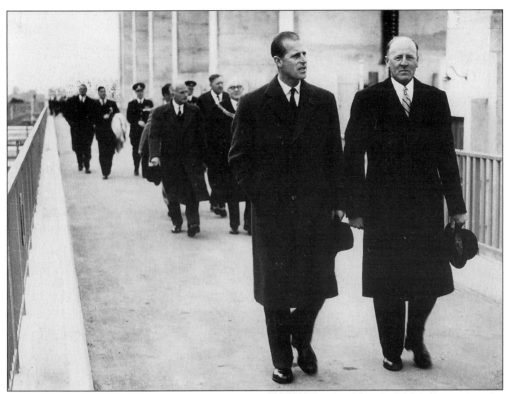

Alderman Leonard Childs, CBE. During the First World War, Leonard Childs saw service as a pilot in the Royal Flying Corps and later took a leading part in the affairs of the British Legion, serving as chairman of the county branch as well as the local branch. A member of a well-known farming family, he was awarded the OBE in 1946 in recognition of his work in the Second World War as county controller of Civil Defence. His knowledge of fen drainage made him an invaluable member of the Great Ouse Catchment Board and he was made chairman following the Great Flood of 1947, a position he held with this board and successive ones for twenty-six years. He was awarded the CBE for his work with the Great Ouse Protection Scheme and this photograph was taken in 1959 when Prince Philip officially opened the Tail Sluice at Denver. A member of the Isle of Ely County Council and the Chatteris Urban District Council, he became vice-chairman and then chairman of each authority, as well as chairman of both Finance Committees and the County Highways Committee. Leonard Childs became a JP in 1937 and eventually chairman of the bench. In 1940 he became high sheriff, in 1950, deputy lieutenant, and in 1952, he was appointed Custos Rotulorum for the Isle of Ely. A keen farmer, he played an important part in the affairs of the National Farmers' Union, and became chairman of both county and town branches. Among his other interests was education, and he was a governor of all the local schools, taking a keen interest in all their activities. A churchman, he was a member of the Ely Diocesan Board of Finance.

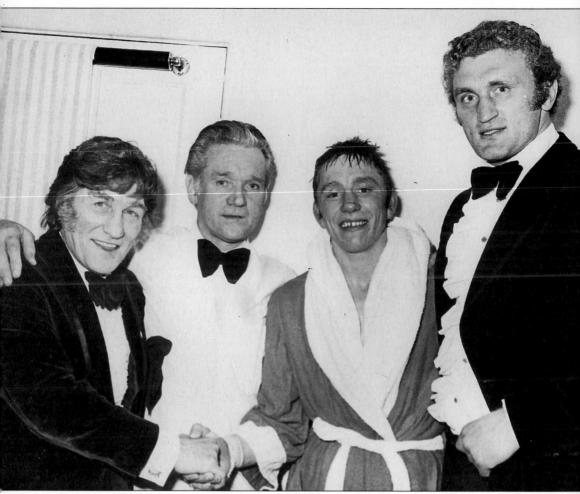

'Boy' Eric Boon shaking hands with Dave 'Boy' Green. Between them is Andy Smith (Green's manager) and on the right stands Joe Bugner.

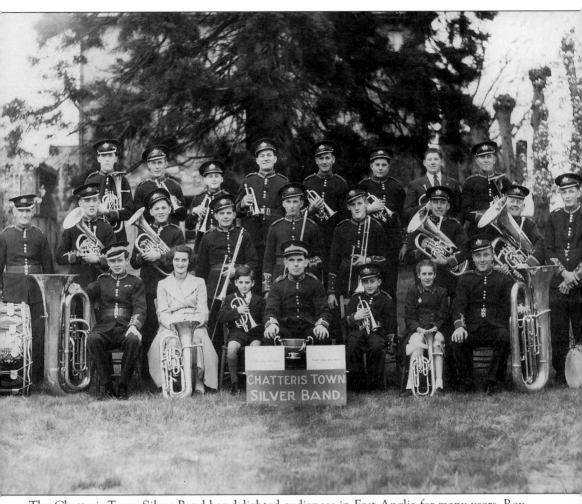

The Chatteris Town Silver Band has delighted audiences in East Anglia for many years. Roy Shilling, on the left of the front row became bandmaster, a position he held for some forty years until his death in 1997.

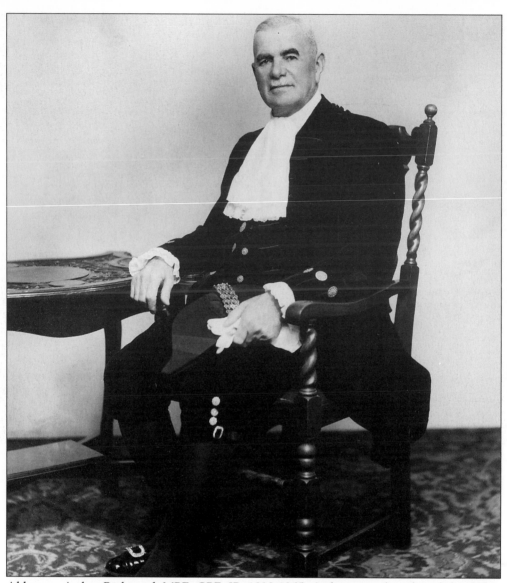

Alderman Arthur Rickwood, MBE, CBE, JP, 1890-1965. Arthur started work with his father who was a farmer and at the age of eighteen was given an acre to work by himself. By 1960, at the age of seventy, he was farming 8,674 acres spread across Cambridgeshire, Norfolk and Suffolk. His main crop was carrots and he became known as 'The Carrot King', producing more carrots than any other farmer in the country. They became a very popular and healthy vegetable to eat, and the surplus were canned or fed to stock. On 6 December 1963, he gave Paradise Farm, Mepal, to the country. The presentation was made to the Rt Hon Christopher Soames, CBE, MP, Minister of Agriculture and Fisheries. The 150 acres were to be used to investigate peat wastage, drainage and other land problems, and known as The Arthur Rickwood Experimental Farm. Alderman Rickwood took a keen interest in local affairs. A devout Christian, he attended the Congregational church all his life and was a Governor of the Westminster Theological College, Cambridge. He was also a town and county councillor and a governor of all the local schools. The picture shows him when he was High Sheriff of Cambridgeshire between 1961 to 1962.

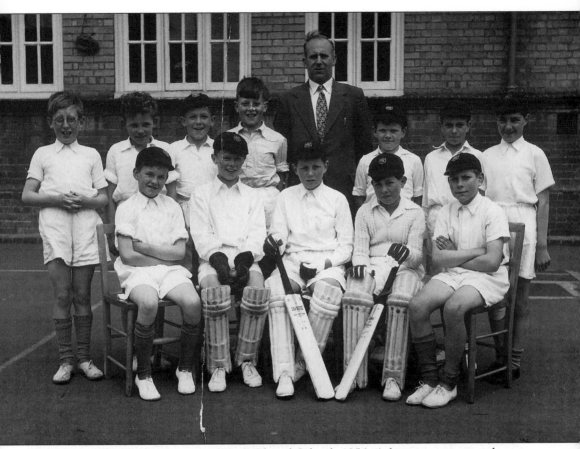

Mr Dennis Hall, the Headmaster of King Edward School, 1956. A keen sportsman and very proud of his young cricket team, which included: Roger Martin, Keith Purcell, George Sharman, Tony Cumbridge, A. Brittan, L. White, Peter Murphy, B. Fisher, Brian Rayner, G. Edgley, R. Munns and T. Rayner.

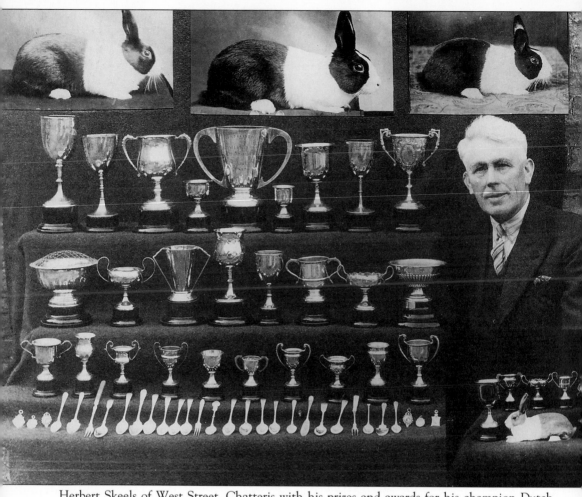

Herbert Skeels of West Street, Chatteris with his prizes and awards for his champion Dutch rabbits.